MW00628439

IMAGES
of America

FORT WORTH'S
QUALITY HILL

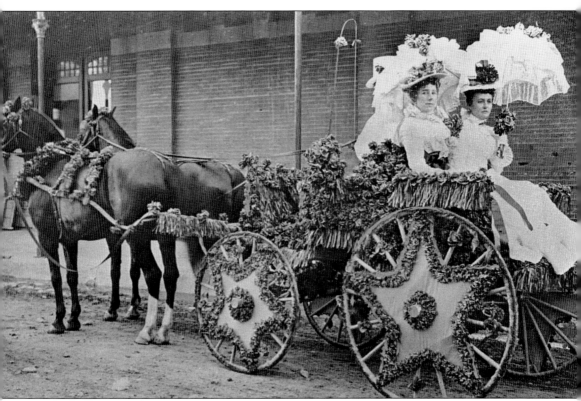

Fort Worth's Parade of Flowers was a major social event beginning in the late 1800s and continuing into the early 20th century. Horses, carriages, and floats were elaborately bedecked with flowers and fringe in celebration of spring. Elizabeth Simmons (left), of Weatherford, and her niece participated in the May 1887 parade. Simmons later wed Winfield Scott and became the mistress of Thistle Hill, one of the finest homes in Fort Worth. (Special Collections, University of Texas at Arlington Libraries, Arlington, Texas/*Fort Worth Star-Telegram* Collection; Historic Fort Worth, Inc.)

ON THE COVER: From April 1 through May 10, 1909, the K.M. Van Zandt family hosted Albert Sidney Johnson, Marjorie Henderson, and Ida Wise during a visit filled with Texas hospitality. All were former classmates of the Van Zandts' daughter Alice at Campbell-Hagerman College in Lexington, Kentucky. Johnson (left) and Alice Van Zandt are pictured in front of the Van Zandt residence at 800 Penn Street. Alice's youngest brother, Sidney, can be seen peeking over her head. (Kenneth McMillan.)

IMAGES
of America

FORT WORTH'S
QUALITY HILL

Brenda S. McClurkin and
Historic Fort Worth, Inc.

ARCADIA
PUBLISHING

Copyright © 2014 by Brenda S. McClurkin and Historic Fort Worth, Inc.
ISBN 978-1-4671-3211-4

Published by Arcadia Publishing
Charleston, South Carolina

Printed in the United States of America

Library of Congress Control Number: 2014930456

For all general information, please contact Arcadia Publishing:
Telephone 843-853-2070
Fax 843-853-0044
E-mail sales@arcadiapublishing.com
For customer service and orders:
Toll-Free 1-888-313-2665

Visit us on the Internet at www.arcadiapublishing.com

We dedicate this book to those working to preserve historic Fort Worth buildings and neighborhoods for generations to enjoy and appreciate.

CONTENTS

ACKNOWLEDGMENTS

Fort Worth's Quality Hill is rooted in work undertaken as a labor of love by many Ball-Eddleman-McFarland House and Thistle Hill staff members and volunteers over a period of three or more decades. Much information was derived from the docent manuals created for those two historic properties. Nancy Connally, Anne Kane, Ruth Karbach, Lisa Lowry, and Brian Rhodes collaborated on the Texas Heritage, Inc., Lost Neighborhood exhibit, which served as the basis of this book proposal. Historic Fort Worth, Inc. staff members Ruth Resurreccion and Brian Rhodes devoted several years in researching Quality Hill properties and locating descendants of Quality Hill residents. Georgette McGar made tremendous contributions in her research for *Gracious Ladies* (1985). The authors are greatly indebted to all those involved in these foundational endeavors.

Special thanks are extended to the following individuals for their assistance and support: Rebecca Bichel, Bess Biddle, Kathryn Cain, Heather Castagna, Pen Cranz, Michelle Cyrus, Alex and Gretchen Denny, Jonathan Frembling, Lisa Helbing, Jennifer Henderson, Mary Jane Ware Howe, Harold Jennings, Tony King, Susan Kline, Dorothy Middleton, Patty Pharis, Amanda Rush, Molly Sauders, Betty Shankle, Cathy Spitzenberger, Kate Stephens, Britt Stokes, McKie Trotter, Barbara Willis, Carol Wood, and Dawn Youngblood.

Images incorporated into this book have been provided courtesy of Acme Brick, Fort Worth; Lee Angle Photography, Fort Worth (LAP); Sissy Brackney (SB); Art Brender (AB); the Cantey family; Lauren Chevalier (LC); Christopher Cornwall (CC); Edmund P. Cranz (EPC); Martin Dahl (MD); the Sam Denny family; Doss Heritage and Culture Center, Weatherford, Texas (DHCC); Genealogy, History, and Archives Unit, Fort Worth Public Library (FWPL); Angela Colvin Gaylord (ACG); Jennifer Gourley (JG); Heart of West Texas Museum, Colorado City, Texas (HWTM); Jennifer Henderson (JH); Historic Fort Worth, Inc. (HFW); Library of Congress (LOC); Chandler R. Lindsley (CRL); Barbara Love Logan (BLL); Anne Marion (AM); Brenda McClurkin (BSM); Kenneth McMillan (KM); Joseph Minton; the Reilly M. Nail Archives of the Old Jail Art Center, Albany, Texas (OJAC); Rosenberg Library, Galveston, Texas (RL); Shirley Ross (SR); Southern Flair Photography, Arlington, Texas (SFP); Texas Hereford Association (THA); Special Collections, University of Texas at Arlington Libraries, Arlington, Texas (UTA), including the *Fort Worth Star-Telegram* Collection (FWST); Arthur Weinman (AW); and the Woman's Club of Fort Worth, Inc., archives chairman Dorothy Middleton, Texas Library chairman Johnnie Drennan, and Texas Library committee member Bess Biddle (WCFW).

INTRODUCTION

In the late 19th century, the Fort Worth elite looked west to the bluffs overlooking both the growing town of Fort Worth and the Clear Fork of the Trinity River to construct exquisite homes that reflected their wealth and prominence in the community. This choice neighborhood, roughly bounded by Seventh Street on the north, Pennsylvania Avenue on the south, Henderson Street on the east, and the Trinity River on the west, would soon become known as Quality Hill. The creative talents of architects such as Howard Messer, Marshall R. Sanguinet, Carl G. Staats, Louis B. Weinman, and Wiley G. Clarkson were granted unlimited budgets to design grand residences with manicured gardens in a new type of neighborhood. The homes featured the finest amenities, including electricity, artesian wells, trolley service, and storage for automobiles.

The pending construction of a new Quality Hill residence was often a newsworthy event. This extract from the December 31, 1902, *Fort Worth Telegram* describes the beginnings of what is known as Thistle Hill, 1509 Pennsylvania, and conveys the tone of the times:

> Plans are being prepared by Architect M.R. Sanguinet for the erection of a magnificent residence on the old Zane Cetti estate, fronting on Pennsylvania avenue, which was recently purchased by E.B. Wharton [sic]. The house will be built in the old colonial style, which has grown in popularity of late, and is to cost between $25,000 and $30,000. Work has begun on the specifications today and they will be completed before the end of January. Mr. Wharton recently came to Texas from the east. He has extensive live stock interests near Decatur, in this state, and is reckoned a millionaire. He paid $30,000 for the land, which comprises six and one-half acres in one of the choicest residence districts of the city.

The men and women of Quality Hill had worked hard to prosper in a dusty, difficult world. This was their place to relax and be seen. They created a social climate that was desired by many, but attained by very few. Future mayors, city council members, and business executives were reared in sailor suits and sent to prestigious boarding schools or military academies. Young ladies, dressed in silks and satins, completed their education in the finest finishing schools. Education and travel went hand-in-hand, culminating in a "grand tour" abroad. Many returned with an appreciation for the finer things yet to be seen in the rough and unsettled West. Homes were filled with European souvenirs, including art, furniture, couture, botanical specimens, and trinkets and baubles of all shapes and sizes. These items set their owners apart and made the homes of Quality Hill the most desirable invitation in the city. Entertaining on a grand and lavish scale became commonplace. Parties, balls, and dinners lasted well into the morning hours and were known to take on themes of foreign lands and discoveries. Out-of-town guests often stayed for days at a time. This excessive living required a staff—nannies, cooks, maids, gardeners, and chauffeurs. House staff often came with an intriguing foreign accent, attire, or appearance. The combination of all of these things created an air of worldliness and good breeding.

The fortunes that built these grand Quality Hill residences were based in cattle, oil, cotton, banking, railroads, the law, and real estate. Those families with large ranches within a short journey to Fort Worth often reserved their home in Quality Hill for weekend retreats during the social season. Much of the city's early philanthropy originated in the parlors of many a hostess. Small private clubs led to bigger charitable missions championing causes for women and children, including the arts, culture, a library, civic beautification, and a day nursery. Men continued to create opportunities for themselves in both business and sport. Many were men of leisure with an entrepreneurial spirit and deep pockets. This led to the introduction of sporting events, livestock competitions, rodeos, automobile clubs, private country clubs, and annual society balls.

Small businesses flourished within Quality Hill; laundresses, grocers, lawyers, and hospitals were all within blocks of the very wealthy. Their close proximity ultimately led to the rezoning and dismantling of almost every fine residence in the district. In the 1920s and 1930s, many families moved to new, prestigious residential areas, such as Ryan Place, Park Hill, Rivercrest, Arlington Heights, and Westover Hills. Larger homes were often transitioned to boardinghouses or apartments, particularly during World War II, to meet the housing demands of defense workers. As the area was rezoned, some residences were repurposed to host a children's theater school, museum, or housing for young women or children. Funeral homes were also established in fine residences, a new trend in mortuary services in keeping with the home funeral practices of the day. Times change, buildings fail, and land values increase. This is a common occurrence when prime real estate is near a growing downtown. Today, Quality Hill is primarily a business and hospital district. Although just a handful of the gracious homes have survived the years, they evoke memories of what used to be.

This book was created by Historic Fort Worth, Inc., in response to the question repeatedly posed by locals and visitors alike: "What did the rest of the neighborhood look like?" The initial effort to reply to this query was the mid-1990s Lost Neighborhood exhibit, created by Texas Heritage, Inc., the nonprofit owner of Thistle Hill prior to the property's donation to Historic Fort Worth in 2006. This book is the culmination of research gathered over many years by numerous Historic Fort Worth staff members and volunteers, past and present. Information has been gleaned from Historic Fort Worth's archives and Preservation Resource Center, libraries, academic institutions, museums and other cultural heritage organizations, professional associations, businesses, and descendants of those who resided in Quality Hill. The intent has been to provide a general overview, not an architectural survey, of the Quality Hill neighborhood, particularly in its heyday from 1890 to 1930. Images beyond those dates have been incorporated to complete the story of a property. Unfortunately, in some instances, the only extant photographs of a residence were taken at the time of its demise. Some prominent addresses are not represented because photographic documentation could not be located.

While much has been lost, many of the structures are well documented and are still in use. When touring the neighborhood, a visitor will find that more than a dozen former Quality Hill residences have been recognized as Fort Worth Historic and Cultural Landmarks, Recorded Texas Historic Landmarks, and entries in the National Register of Historic Places. The memories and available documentation all yield one result: the legacy of Quality Hill and its early citizens became the cornerstone for Fort Worth's rich architectural heritage, art appreciation, philanthropy, and overwhelming hospitality.

One

PENN STREET

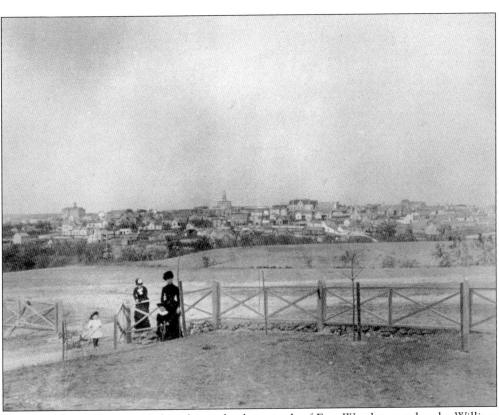

Historians have determined that this early photograph of Fort Worth was taken by William Somerville, a Matagorda Land & Cattle Co. and Texas Spring Palace executive, sometime in 1885. His residence, located on the west side of Penn Street between Jackson and Thirteenth Streets, provided a panoramic view of the growing town. The individuals pictured here are, from left to right, Somerville's son Harold; his wife, Mary; his son Alfred; and Lizzie Campbell of Matador, Texas. (UTA/Jack White.)

Attorney K.M. Van Zandt moved with his parents to Texas from Tennessee in 1839. After Confederate army service, he ventured to Fort Worth in 1865, finding it a "sad and gloomy picture." He helped organize Tidball, Van Zandt & Company, later Fort Worth National Bank. Other business interests included railroad construction, insurance, newspapers, ranching, and land investments. He served in the Texas legislature, on the Fort Worth school board, and in other civic organizations. (UTA/W.D. Smith.)

Van Zandt built this two-story brick residence at 800 Penn Street, on a 10-acre site at the southwest corner of Seventh and Penn Streets, around 1879. The bricks utilized in its construction were made with clay taken from the nearby Trinity River. The mistress of this household was Van Zandt's second wife, Mattie. The property was conveniently located between his business interests downtown and extensive land holdings to the west. (EPC.)

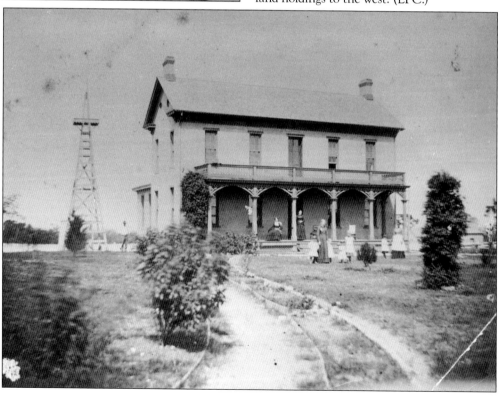

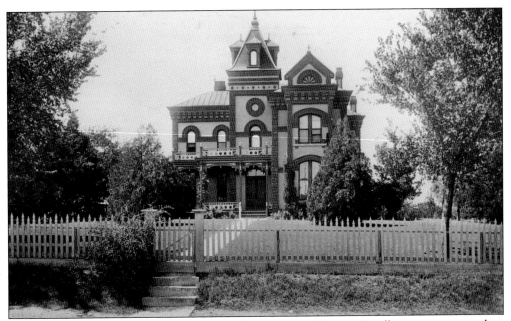

Following the death of his wife Mattie, Van Zandt married Octavia Pendleton, a young teacher, in 1885. That same year, the Van Zandts extensively remodeled their home, increasing its square footage and updating the exterior to an eclectic Victorian style. The original front porch was removed, and eight rooms, a central tower, and gingerbread detailing were added, drastically changing the exterior appearance. (UTA/FWST.)

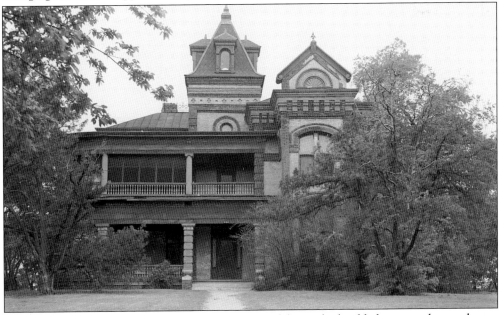

The Van Zandt home is seen here after a 1900 remodeling, which added a covered second-story balcony and a glass front door with leaded sidelights. The Van Zandts employed an artist to create vibrantly colored trompe l'oeil paintings of cherubs, authors, and composers on the parlor ceilings, giving the illusion of an exquisite, three-dimensional design. Having been damaged by fire, the house was sold in 1963 and demolished the following year. (UTA/FWST.)

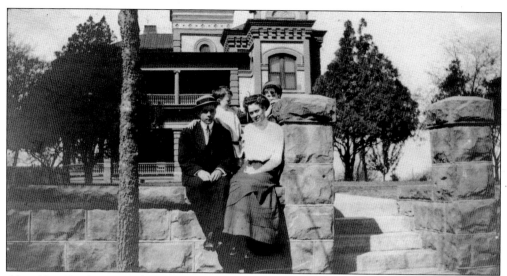

Alice Van Zandt attended Campbell-Hagerman College in Lexington, Kentucky. From April 1 through May 10, 1909, Alice and her family hosted houseguests, former Campbell-Hagerman classmates Marjorie Henderson of St. Paul, Minnesota; Albert Sidney Johnson of Lawrence, Kentucky; and Ida Wise of Millersburg, Ohio. Pictured above are Sidney Johnson (left) and Alice Van Zandt in front of the K.M. Van Zandt residence at 800 Penn Street. Alice's youngest brother, Sidney, is seen peeking over her head. Marjorie Henderson kept a diary in which she recorded detailed accounts of her Fort Worth trip, including dinner parties, dances, bridge games, and a trip to the Zandtland ranch. On April 3, 1909, family and guests raced to the tower of the Van Zandt residence to view the spectacular fire engulfing the Texas & Pacific Railway roundhouse and passenger depot (below). (Above, KM; below, UTA/FWST.)

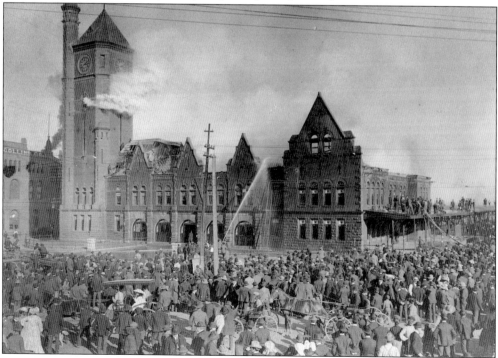

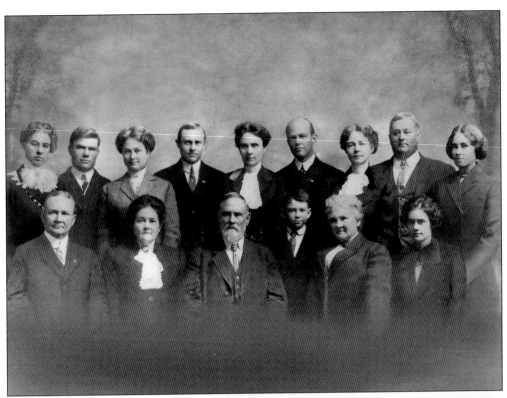

K.M. Van Zandt fathered a total of 14 children by his three wives. All of the children gathered for a family portrait (above), published in *Confederate Veteran* magazine. Pictured are, from left to right, (front row) K.M. Jr., Florence (Jennings), K.M. Van Zandt, Albert Sidney Johnston, Mary Louisa (Hendricks), and Margaret Colville (Miller); (second row) Alice (Williams), Edmund Pendleton, Virginia (Diboll), Elias Beall, Ida (Smith), Richard L., Annie (Attwell), Isaac, and Frances Cooke (Sloan). The stunning portrait of mother and child (right) shows Fannie Van Zandt Sloan and her daughter Jane. The photograph was taken in the K.M. Van Zandt residence at 800 Penn Street around 1916 or 1917. (Both, EPC.)

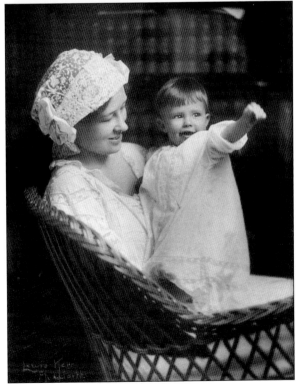

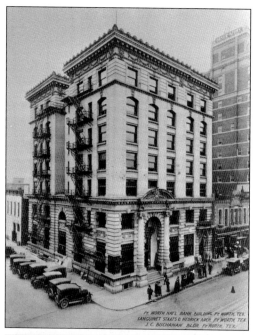

In 1874, Van Zandt and partners formed the banking firm Tidball, Van Zandt & Company. Its successor, Fort Worth National Bank, was organized in 1883, with Van Zandt as president. In 1904, the Fort Worth National Bank moved to this seven-story building at Fifth and Main Streets, continuing operation there until 1927, when it moved to a 24-story building on the northwest corner of Seventh and Main Streets. (UTA/FWST.)

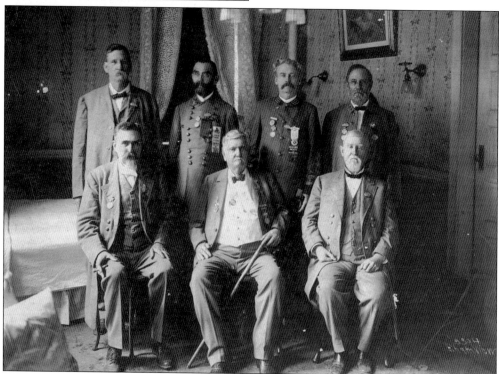

K.M. Van Zandt, frequently referred to as "Major" Van Zandt, was a revered Confederate Civil War veteran. B.B. Paddock (second row, second from right) and Van Zandt (second row, far right) traveled by special train in June 1908 to represent the Robert E. Lee Camp No. 158, United Confederate Veterans (UCV), at the national UCV meeting in Birmingham, Alabama. Former Dallas mayor William L. Cabell is seated in the center. (UTA/Paddock Papers.)

Leroy Smith and his wife, Ida, eldest daughter of K.M. and Mattie Van Zandt, lived in two different houses at 820 Penn Street. The earlier home featured distinctive white porch columns. It is pictured at right, viewed from the neighboring Van Zandt residence at 800 Penn Street. Smith advertised for a cook for a small family at this address in December 1905. In August 1914, he offered his seven-room house for sale. The advertisement claimed it was a "good house," insured for $3,500, but had to be moved. The shingle-roofed, chocolate brick home (below), designed by architect Wiley Clarkson, was completed shortly thereafter. (UTA/FWST.)

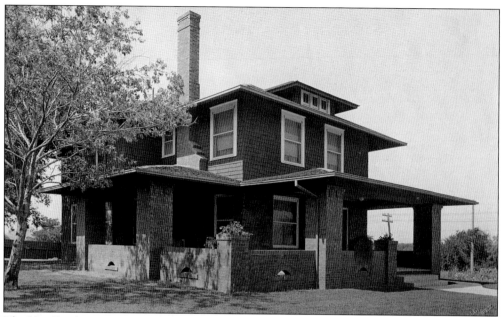

The Van Zandt estate at 800 Penn Street included homesites at the rear of the property for three other Van Zandt children: Alice Van Zandt Williams, Elias Beall Van Zandt, and Virginia Van Zandt Diboll. The archives of the Acme Brick Company yielded this photograph of the Elias Van Zandt residence, thought to be among them. The two-story, Prairie-style brick home was situated between those of his sisters. (Acme Brick.)

Although not on the scale of its neighbors, the house at 904 Penn Street is important, as it is said to have been the oldest brick house in Fort Worth. Colonel Griffin built what was originally a two-room home in 1865 with brick made with mud from the neighboring Trinity River. Subsequent owners included S.W. Sullivan, Dr. William Crawford, and Paul deCleva. The house was razed in 1964. (UTA/FWST.)

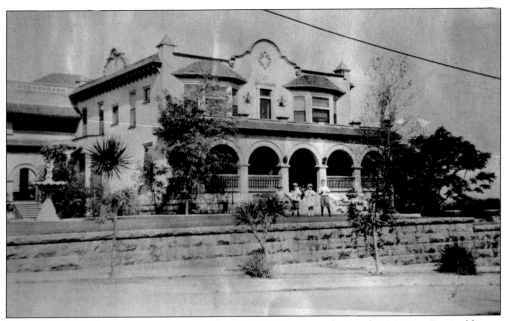

Banker Otho S. Houston commissioned Louis B. Weinman to design this Mission Revival home at 914 Penn Street. The stucco residence with red-tile roof was under construction in 1903 when Houston became president of Hunter-Phelan Savings. The home was sold to Frank Marion Weaver, a cattleman and director of the Fort Worth National Bank. Rented out during World War II, the house was demolished in the 1960s. (JH.)

Frank Weaver, along with son James A. Weaver and Walter Morris, bought the Fort Worth Panthers baseball franchise from William H. Ward in 1909. Weaver sold the Cats franchise to a syndicate headed by Paul LaGrave and W.K. Stripling in 1916. Baseball fans could follow the progress of out-of-town games by monitoring this manually operated play-by-play score box on the front of the *Fort Worth Star-Telegram* building, pictured in 1909. (UTA/FWST.)

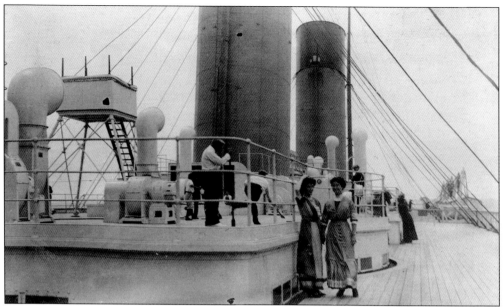

In June 1914, Weaver daughter Katherine Weaver Rose (right) and her cousin Edna Lewis (left) traveled to Berlin to study music over the summer. World War I erupted around them in late July, and the two had great difficulty returning home. Kate and Edna sailed from Liverpool on the steamship *New York*, arriving in New York on September 4. The cousins are seen aboard ship, thought to be during one leg of this trip. (JH.)

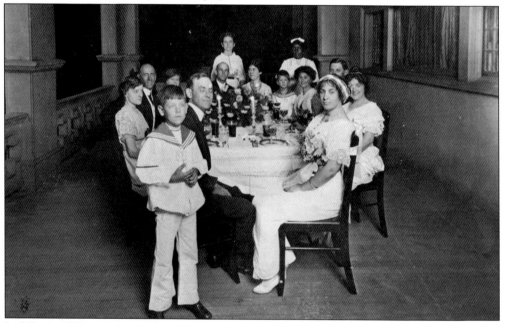

Juel Eugene Weaver married his second wife, Helen Elizabeth Bain, in 1912. Family and friends joined the bride and groom for an elegant dinner on the front porch of the Weaver residence. Guests included Katherine Weaver Rose and her beau, Guy Waggoner, seated at the far end of the table; Dorothy Weaver, standing at left behind the table; and Frank Weaver Rose, the child wearing the sailor suit. (JH.)

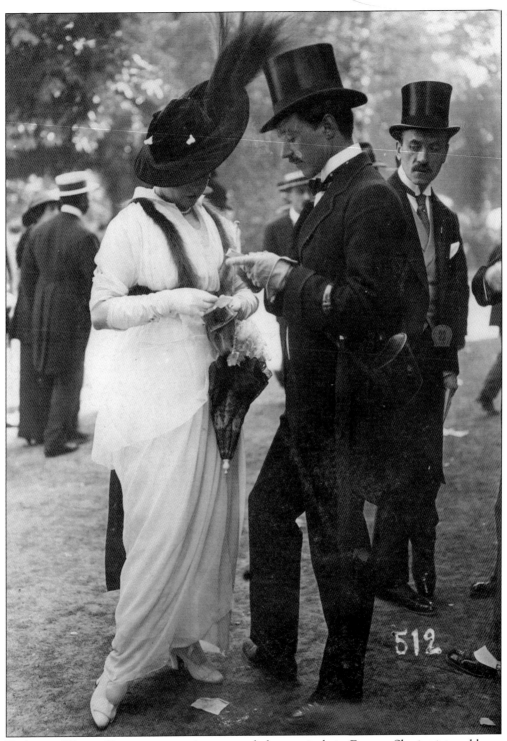

Katherine Weaver Rose, an opera singer, traveled extensively in Europe. She is pictured here, elegantly attired, in an undated photograph taken in London probably while attending a horse race. Her dashing companions are unidentified. (JH.)

Dorothy McCarty Weaver is pictured above on the front steps of her Penn Street residence. The graceful arches and balustrade of the home's full-length porch are clearly shown. Weaver was, at one time, state superintendent of scientific temperance instruction for the Texas Woman's Christian Temperance Union. She died in her home in August 1919, leaving an estate estimated at $800,000 to her four children and the First Church of Christ, Scientist. Her husband remarried in 1921 to Louie Hardison. Below, Frank Weaver (center) is flanked by his four children. They are, from left to right, John Roderick Weaver, Juel Eugene Weaver, Dorothy Katherine Weaver Rose, and James Anderson Weaver. Frank Weaver died in 1936 at the age of 83. His estate included a 35,000-acre ranch in Dawson County. (Both, JH.)

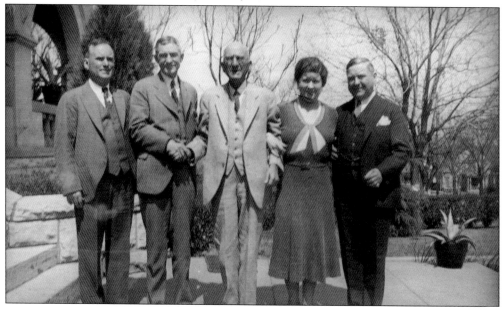

Charles Herbert Silliman was president of the board of trade and manager of the Land Mortgage Bank of Texas, a financial enterprise consisting of English investors. A New York native, Silliman was formerly a teacher and lawyer who arrived in Fort Worth in 1889. His other business interests included the Fort Worth Stock Yards Company and Texas real estate. He was active in several Masonic orders and was a deacon at First Baptist Church. (BSM.)

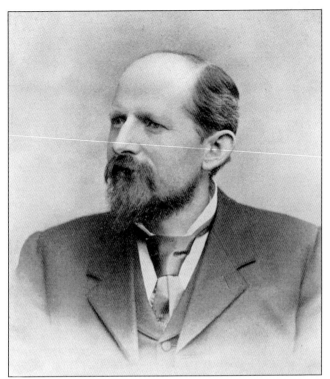

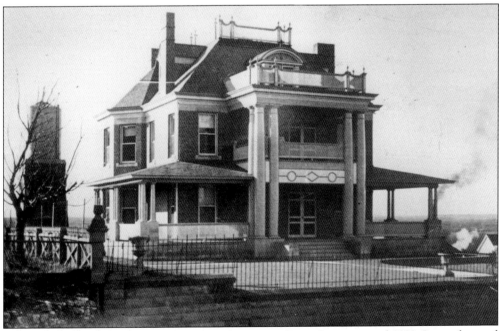

Silliman built this Colonial Revival mansion at 1008 Penn Street around 1892. It was featured in an 1896 brochure published by architects Sanguinet and Staats. The "granitic pressed-brick residence with stone trimming" overlooked the Trinity River. Parlors, a library, and a dining room were located on the first floor; bedrooms and a billiard room were on the second floor. The third floor almost entirely consisted of Elizabeth Silliman's art studio. (UTA.)

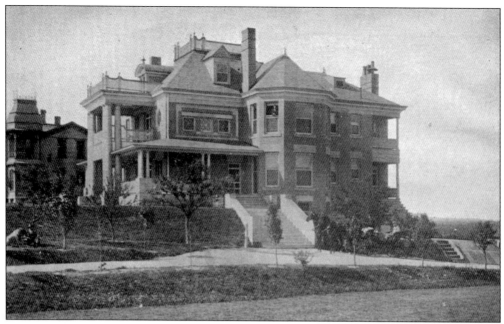

The Silliman residence was featured in a 1900 issue of the *Bohemian*, a quarterly Fort Worth literary publication. This photograph, depicting the home's north elevation, clearly shows that the house was situated on a large acreage known for its exquisite views. The residence was known as the "Somerville Place," likely the locale from which the 1885 Fort Worth photograph on page nine was taken. (UTA.)

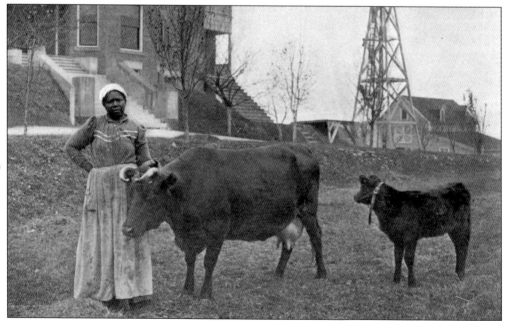

The Sillimans had farm animals on their Penn Street property. Aunt Fanny, a member of the Silliman family staff, is pictured here with Bossy and her calf Bessy on the side lawn. The building on the far right may be a barn or a carriage house. The *Bohemian* described turkeys living on-site, along with dogs Ras and Brave. (UTA.)

The *Bohemian* reported that the Silliman house was "furnished with excellent taste." The hall of the home, with its dark wood paneling, heavy draperies, and deer trophies, had a masculine feel. The house was lighted by electricity and supplied by a deep artesian well. (UTA.)

The comfortable first-floor library was furnished with tufted leather sofas and chairs. A partners' desk was positioned underneath the chandelier in the center of the room. An elaborate overmantel set off the tile-faced fireplace. Books, a mantel clock, porcelain vases and figurines, and animal rugs completed the furnishings. Elizabeth Silliman passed away in 1900; her husband left Fort Worth in 1903. (UTA.)

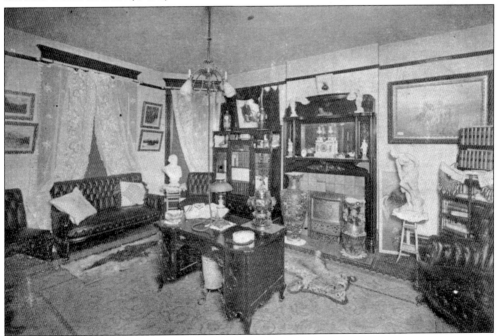

Newton Hance Lassiter moved to Fort Worth in 1885 and became a successful attorney, representing large railroad companies headquartered in Fort Worth, including the Cotton Belt Railroad Company; Fort Worth & Rio Grande Railroad Company; Chicago, Rock Island & Texas Railway Company; and Trinity & Brazos Valley Railway. *Greater Fort Worth*, published in 1907, identified 1008 Penn Street as the N.H. Lassiter residence. (UTA.)

This photograph shows 1008 Penn Street as Lassiter Lodge, a Girls Service League home for employed young women. The house and part of the property were later sold to the Harbor Club, Inc. The First Presbyterian Church congregation voted in 1952 to acquire the former Silliman estate from the Girls Service League and Harbor Club, planning the education building on the high ground and recreation areas for the sloping wooded areas. (UTA/FWST.)

Cattleman Byron Crandall Rhome moved to Fort Worth from his Wise County ranch around 1896. He helped found the Fort Worth Fat Stock Show that same year, and served as president of the Texas Hereford Association from 1904 to 1905. Rhome purchased the lot at 1024 Penn Street in 1897 and constructed a stately Queen Anne residence (below) in 1902. Like that of his neighbors, the Rhome property overlooked the Trinity River, and its outbuildings, servants' quarters, and carriage house were located below the bluff, out of view. Rhome's son Romulus John Rhome was a Fort Worth businessman and banker. In 1908, he organized the North Texas State Bank and succeeded his father as president of the Guaranty State Bank. Romulus and his family lived at 1024 Penn Street following his father's death. First Presbyterian Church acquired the homesite in the 1950s for its new sanctuary. (Right, THA; below, JG.)

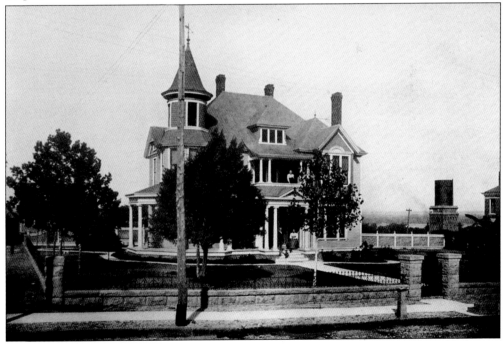

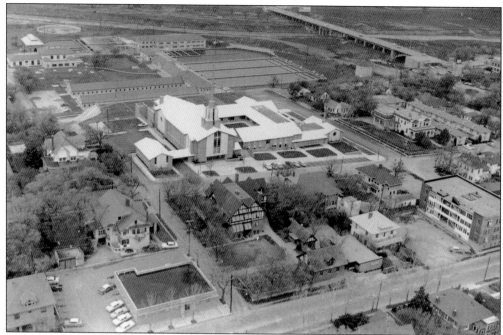

In the 1950s, First Presbyterian Church acquired the former Rhome and Silliman-Lassiter residences for its new campus. This Gordon Smith aerial photograph, taken about 1957, shows the new church and the surrounding residential properties still in place: the Houston-Weaver residence to the right, the Willard Burton residence to the left, and the Googins, Anderson, and Schenecker homes in the foreground. Note the city water-treatment plant below the bluff. (HFW.)

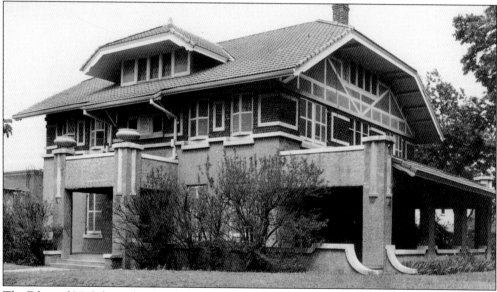

The Edmund M. Schenecker family lived in this Tudor Revival stucco home at 1015 Penn Street, pictured here in 1950. Schenecker came to Fort Worth in 1893 with Nave-McCord Mercantile Company. He retired in 1927 as vice president and general manager of the James McCord Company, a wholesale grocer. His wife, Clara Schenecker, was the sister of Mary Whitla Anderson, who lived next door at 1025 Penn Street. (UTA.)

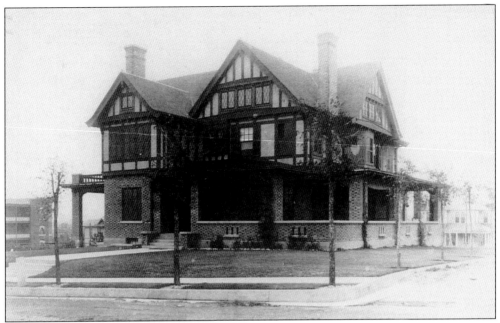

Bernie Letcher Anderson, son of cotton broker Neil P. Anderson, built this three-story Tudor Revival home at 1025 Penn Street in 1907. The house occupied two lots extending from Penn Street to Summit Avenue. The building permit was issued for a $20,000 residence with 12 rooms. The house featured a third-floor ballroom/gymnasium and an early intercom system. The house was demolished in 1963, two years after Anderson's death. (HFW.)

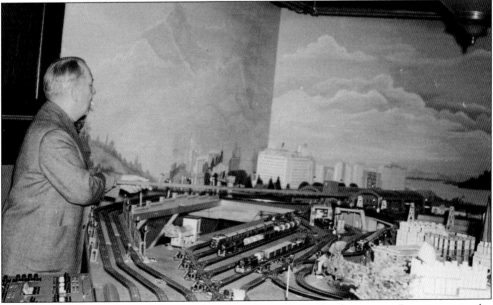

Bernie Anderson built an elaborate electric train model in his basement. Prominent in the background mural is the Neil P. Anderson building, completed in 1920 and named for Bernie's father. The layout included an interesting feature: when water was added, a waterfall flowed into a lake, causing duck figures to rise to the surface. A liquor vault accommodating 600 bottles was added to the basement in 1918 and was fully stocked during Prohibition. (HFW.)

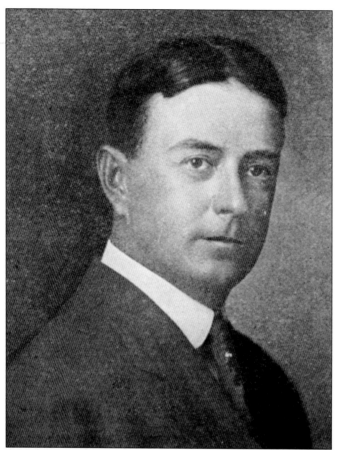

A November 1906 newspaper article reported that a new residence for Joseph Boynton Googins was being constructed at Thirteenth and Penn Streets by J.W. O'Gwin. Completion of the $15,000 home was expected before Christmas. It was described as having a first story of stone, a second story of slate, and a tile roof. The roofline was asymmetrical. From the front, the north side of the roof was a straight gable; the south side was gambrel-shaped, which highlighted an interesting eyebrow opening for the master bedroom balcony on the southwest corner of the house. The portrait of Googins at left appeared in the book *Makers of Fort Worth*, a 1914 publication of the Fort Worth Newspaper Artists Association. (Left, UTA; below, CRL.)

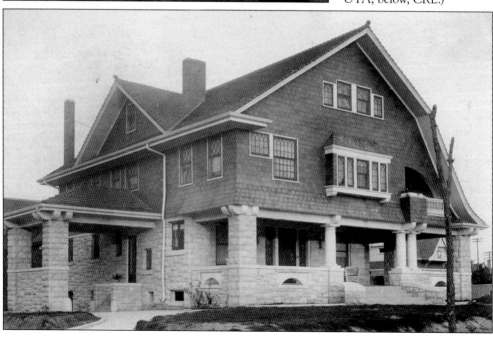

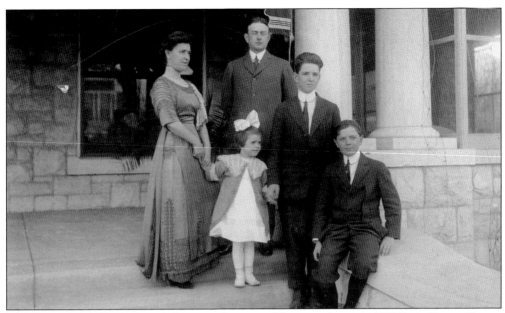

The Googins family is pictured above on the steps of their new home at 1101 Penn Street. Shown here with Ruth Swiler Googins and J.B. Googins are their daughter Ruth and sons David (second from right) and John. Behind them, a beveled glass front door flanked with sidelights opened onto a large living room (below). The stairs on the far side of the room led to the second-floor bedrooms, library, and conservatory, and then to the third-floor ballroom. A second stairway underneath the main staircase accessed the basement and its swimming pool. Entrance to the dining room was made through a pair of pocket doors to the right of the fireplace. French doors opened from the living room to the screened porch on the south side of the home. (Both, CRL.)

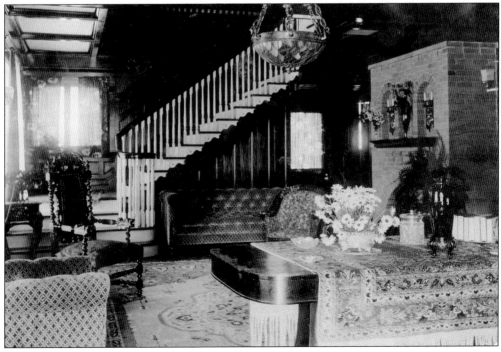

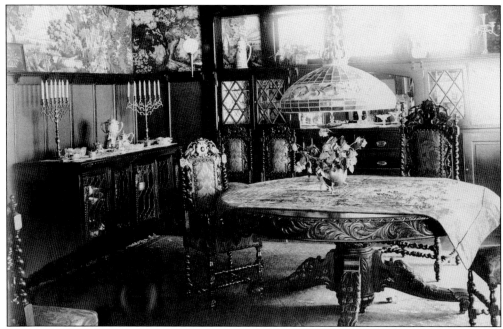

The focal point of the elegant wood-paneled dining room (above) was a set of furniture with an affiliation to friends, the Marshall Field family of Chicago. The heavily carved, round walnut table expanded to accommodate a large dinner party seated in two master chairs and ten side chairs. Glass-front sideboards stored multiple sets of dinnerware. A Tiffany leaded-glass chandelier illuminated the table. The curved south wall of the dining room was composed of beveled leaded glass and two stained-glass windows. The Googins family and chauffeur are pictured below in their touring car, ready to depart on a journey. The porte cochere on the north side of the house sheltered the family from sun and rain as they departed or arrived home. The driveway that passed beneath it gave the vehicle easy access to both Penn and Thirteenth Streets. (Both, CRL.)

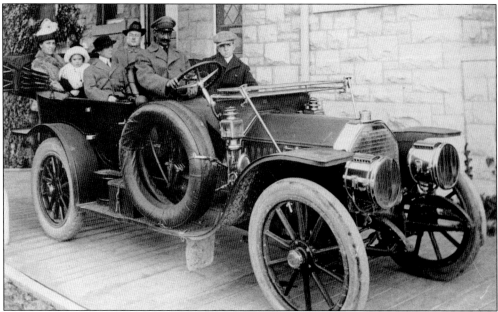

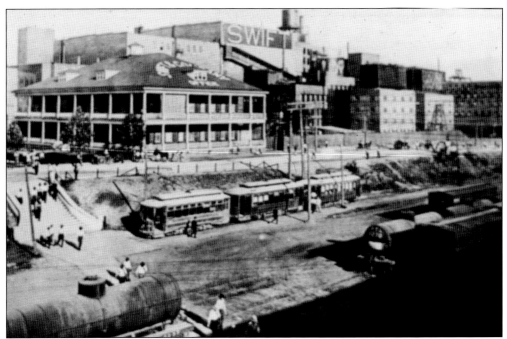

A Chicago native, Googins had been associated with Swift & Company since 1900. He moved to Fort Worth in 1902 to become manager of the new Swift packing plant on the city's northside. He was also a director of the Fort Worth Stockyards Company, Stockyards National Bank, the chamber of commerce, and the Southwestern Exposition and Fat Stock Show. Socially, he belonged to River Crest Country Club. The Swift facility at the Fort Worth Stockyards is shown above in an undated photograph. In 1909, Googins commenced construction of the Googins Block (below), an office building that still stands on North Main and Twentieth Streets. Southwest Mechanical Company played a role in its construction. Googins died suddenly in October 1922, leaving an estate of approximately $500,000. (Above, UTA/FWST; below, UTA.)

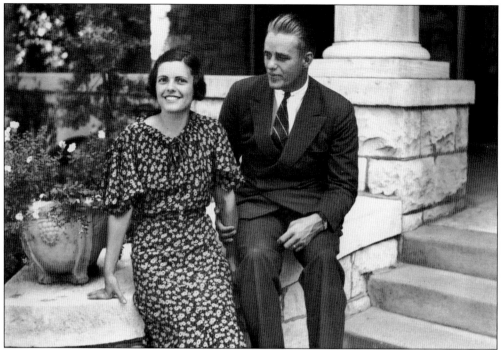

Daughter Ruth Googins married Elliott Roosevelt, son of Pres. Franklin Delano Roosevelt and his wife, Eleanor. The newlyweds are pictured above on the front steps of the Googinses' Penn Street residence on September 16, 1933. He gazes adoringly at her; she radiates happiness. The home at 1101 Penn Street stood until it was demolished to provide parking for the new First Presbyterian Church in 1952. The house is pictured below in diminished condition, as featured in a 1950 article in the *Fort Worth Star-Telegram* about the Penn and Summit Street homes. (Both, UTA/FWST.)

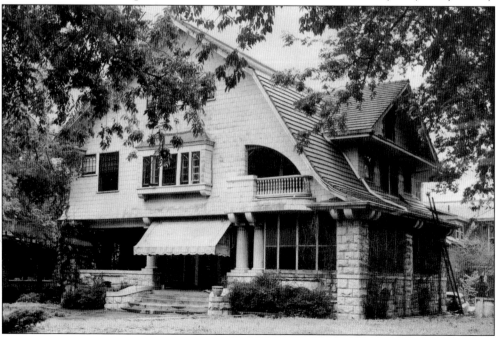

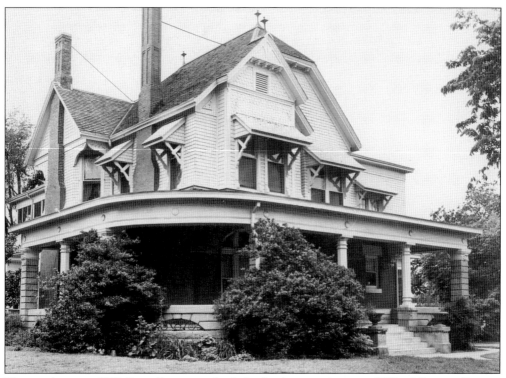

The residence at 1102 Penn Street was built for lumber entrepreneur Willard Burton. Burton moved to Fort Worth in 1873, where he was employed by the William Cameron Company for 14 years. He was a passenger on the first train that rolled into Fort Worth in 1876. By 1890, he founded Burton-Lingo Company with cousins E.H. Lingo and Paul and John Waples. In great disrepair, the Burton property was acquired by First Presbyterian Church and razed in 1960. Willard Burton was named mayor of Fort Worth in October 1924 at the age of 75. He was among the nine men elected to Fort Worth's first city council on April 15, 1925. The newly elected councilmen gathered for the group portrait below. Burton is standing in the front row, hat in hand. (Both, UTA/FWST.)

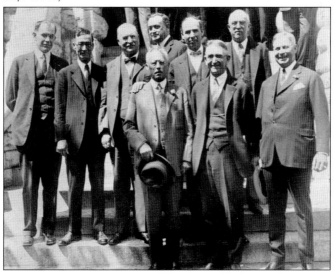

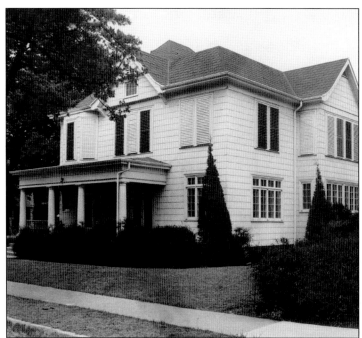

Wharton Davenport moved from Galveston to Fort Worth in 1900, shortly after the hurricane that tragically claimed the lives of three of his children. He was a partner in Davenport and Batterson, a wholesale brokerage and commission merchant. Davenport was living at 1111 Penn Street at the time of his death in November 1902. By 1950, 1111 Penn Street housed the St. Ann's Business Club, a nonprofit organization providing resources to working women. (UTA/FWST.)

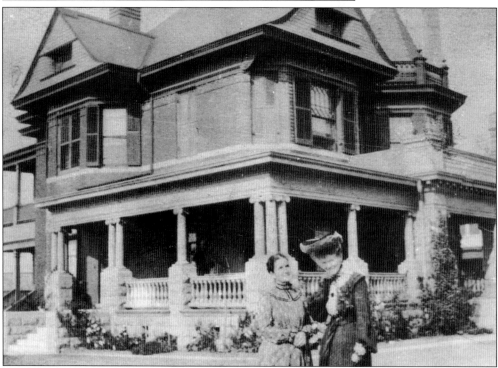

The design of this Queen Anne home at 1120 Penn Street is attributed to architect Howard Messer. It was built in 1898 for Joseph Pollock, an Illinois-born homeopathic physician who had practiced medicine in Fort Worth since about 1886. The two-story Pollock house survives today as the Dent Law Firm. Constructed of red brick and limestone, it features a hexagonal corner tower and a red and gray slate roof with copper cresting. (LOC; UTA.)

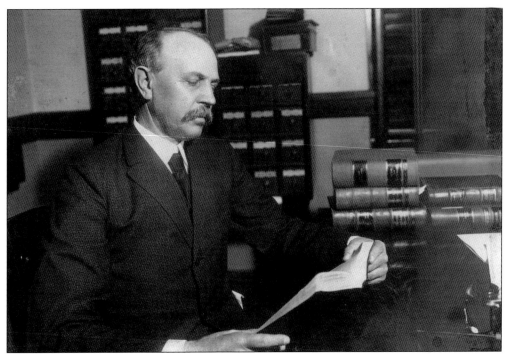

When Dr. Pollock fell ill with heart disease, he and his wife moved one block east to 1120 Summit Avenue, where they lived with their daughter. William and Sallie Capps purchased the Pollock house in February 1910 for $25,500. Capps (above) was a prominent attorney in the firm Capps and Cantey (later Capps, Cantey, Hanger & Short), a real estate developer, and president of the *Fort Worth Record* newspaper. He was also a prime investor in Fort Worth's southside and gifted land to the city of Fort Worth now known as Capps Park. The photograph at right shows the Capps children, Mattie Mae (left), Count Brooke (center), and Alba. Note the streetlight behind them at the intersection of Penn Street and Lancaster Avenue (formerly North, or Front Street). (Above, HFW; right, UTA/Sallie Capps Papers.)

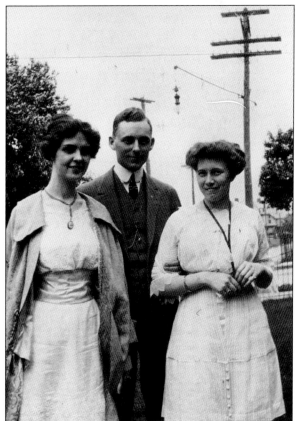

The Capps family remodeled the house in 1910, enlarging and enclosing the porch, adding two bedrooms, another bath, a conservatory, and a porte cochere. The grounds at one time also included a barn for horses and cows, a three-car garage with a ballroom above, a golf course, and a tennis court. Mattie Mae married Frank Anderson in a society wedding in 1913. The Andersons, along with their adopted son William, shared the house with her parents. (LOC.)

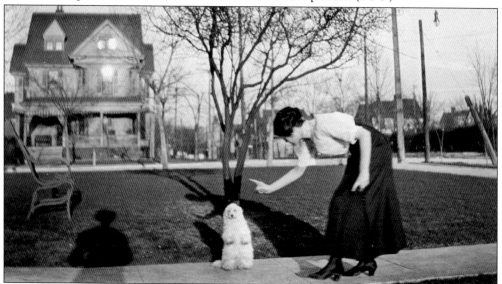

This photograph of Mattie Mae Capps training her little white dog also captures the front of the Horace H. Cobb residence, across the street at 1119 Penn Street. Horace Cobb, a native of Vermont, practiced law in Michigan before moving to Fort Worth in 1890. In Fort Worth, he was manager of the Belcher Land Mortgage Company for over 20 years and a principal in the Cobb Brick Company. (UTA/Sallie Capps.)

36

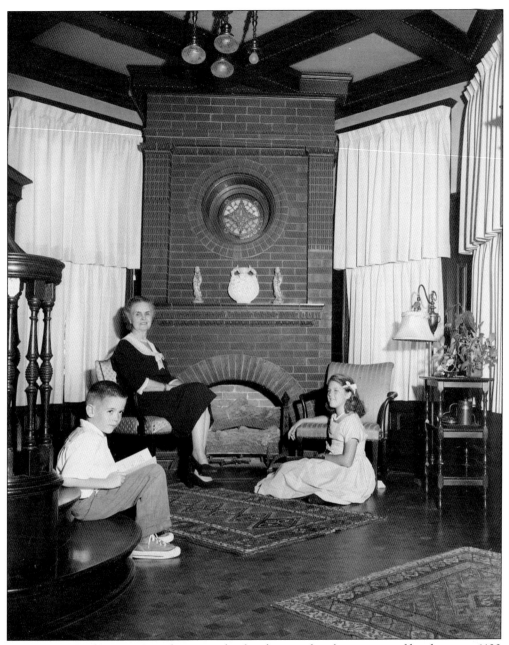

Mattie Mae Anderson is seated next to the fireplace in the alcove room of her home at 1120 Penn Street in June 1958. She first moved into the house with her parents, William and Sallie Capps, in 1910. The Capps family purchased the property from Dr. Joseph R. Pollock and moved to Penn Street from 1212 Summit Avenue. Also shown here are Anderson's grandchildren Billy Anderson (left) and Carolyn Anderson. Note the circular window above the fireplace, a distinctive architectural feature visible from both inside and outside the house. (UTA/FWST.)

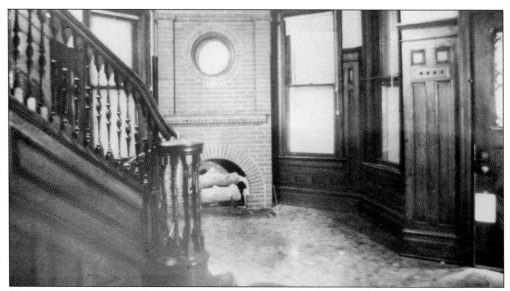

The exterior elevations and interior floor plans of the Pollock-Capps House were documented for the Historic American Building Survey (HABS) by the School of Architecture at the University of Texas at Arlington. The above photograph of the alcove room and the main staircase, just inside the front door of the residence, was taken during the HABS study. Frank Anderson, who had survived his wife and in-laws, moved to the Fort Worth Club in 1971. Historic Fort Worth, Inc. acquired the property at that time. The Pollock-Capps residence was soon after restored to its original appearance. (Above, LOC; below, HFW.)

Two

Ball-Eddleman-
McFarland House
1110 Penn Street

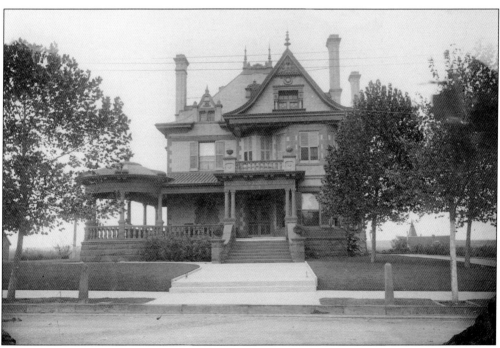

The residence at 1110 Penn Street was designed by English architect Howard Messer for wealthy Galveston widow Sarah Ball and her son Frank. The Balls moved to Fort Worth to enjoy a more healthful climate. Begun in 1899, the home was cited in a Fort Worth newspaper as a "modern palace." The Ball residence was completed the following year at a cost of $38,000. (HFW.)

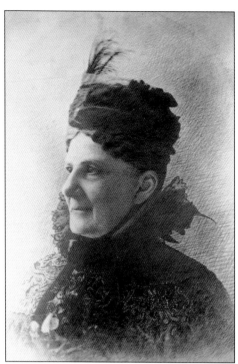

Sarah Catherine Perry married George Ball in April 1848. Ball had arrived in Galveston in 1839 and, over the years, expanded a mercantile business into investments in cotton brokerage, banking, real estate, railroads, and shipping. At the time of his death in 1884, George Ball had amassed enormous wealth for his family. Sarah Ball designed a new Fort Worth home that would reflect her affluence, stability, and social standing. (RL.)

George and Sarah Ball generously shared their wealth with others. An example of their philanthropy was the gift of funds to build Galveston's Ball High School (pictured). Sarah Ball provided additional funding for interior decoration and furnishings for the school after her husband's death. The Ball munificence continued in Fort Worth with charitable gifts to, among others, Broadway Presbyterian Church, forerunner of St. Stephen Presbyterian Church. (RL.)

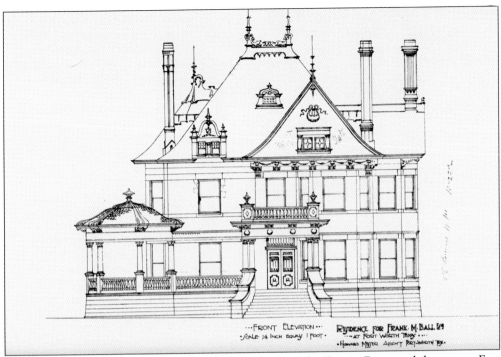

··· FRONT ELEVATION ···
· SCALE ¼ INCH EQUALS 1 FOOT ·

RESIDENCE FOR FRANK M. BALL E9
··· AT FORT WORTH TEXAS ···
· HOWARD MESSER ARCH'T FORT-WORTH TEX ·

Sarah Ball selected a lot situated on a bluff overlooking the Trinity River and downtown Fort Worth. The carriage house, servants' quarters, and mechanical building were constructed on the hillside, hidden from the street. She favored the Queen Anne architecture prevalent in Galveston over the clean lines and symmetry of the emerging Classical Revival style. Messer's design included an asymmetrical wraparound porch and featured Pennsylvania pressed brick, Colorado red sandstone, slate roofing, and copper ridges, finials, and eaves, all natural, fire-resistant exterior materials. The home was originally built with one bathroom. A chamber dressing area that opened onto the front second-floor gallery was converted to a second bathroom sometime between 1913 and 1915. Frank Ball died suddenly in 1901. His mother lived in the house until her death in 1904. (Both, HFW.)

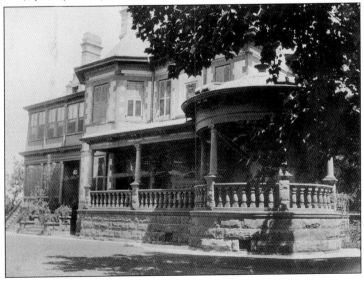

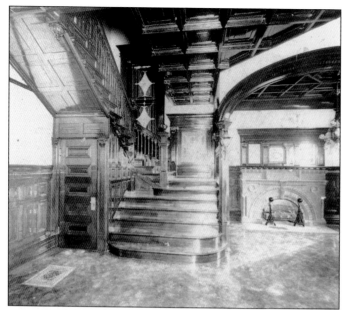

This photograph of the main staircase and alcove room (or inglenook) near the front entrance appears to have been taken at the time the house was completed. Public and family spaces featured fine oak and mahogany woodwork. Intricate pilasters, cornices, brackets, moldings, and coffered ceilings were selected from pattern books, made by machine, and finished on-site. This exquisitely crafted woodwork has remained largely unaltered over the home's 100-plus-year history. (UTA/FWST.)

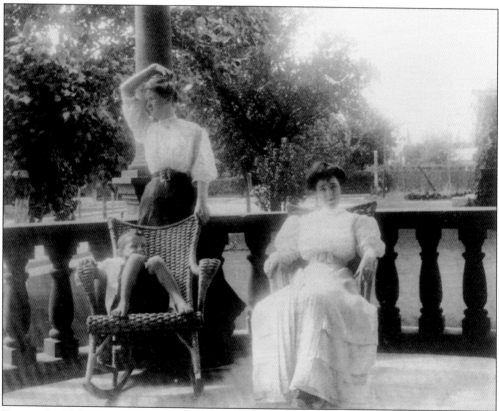

During the 19th century, porches became an extension of the interior living space. Here, Carrie Eddleman McFarland (right) relaxes on her spacious porch with unidentified friends not long after moving to Fort Worth in 1905. The house was not air-conditioned until the 1950s, so the front porch was the perfect place of respite from the summer heat. (HFW.)

William Harrison Eddleman, son of a
Methodist minister, accompanied his
family to Parker County around 1851. As
a young man, he drove cattle with Oliver
Loving. His early Weatherford commercial
interests included co-ownership of the
mercantile firm Ross, Eddleman &
Company and, later, the cotton and wool
commission house Eddleman & Davis.
He also invested in the Weatherford
Cotton Compress, Crystal Palace Flour
Mill, and cattle ranch lands. (HFW.)

Sarah Eddleman was the daughter of
Weatherford physician and early mayor
Dr. Stephen Dorris Conger. She married
W.H. Eddleman in 1877; their daughter,
Caroline "Carrie" Aurelia, was born
the following year. Sarah was a charter
member of the Twentieth Century Club in
Weatherford, and was active in the Wednesday
Club and American Red Cross in Fort Worth.
This photograph was taken at New York's Waldorf-
Astoria Hotel around 1910. (HFW.)

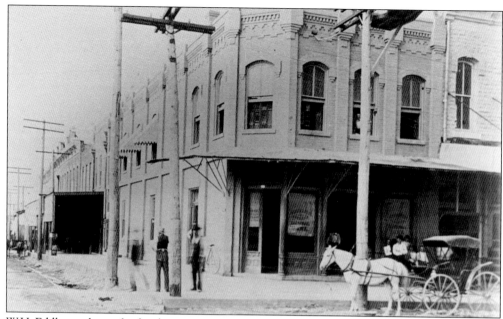

W.H. Eddleman began his banking career in 1882 in Weatherford as a director of Citizens National Bank, then as director and vice president of First National Bank from 1886 to 1888. On March 15, 1889, Eddleman chartered Merchants & Farmers National Bank and served as its president until 1915. Originally located on the southwest corner of the Weatherford courthouse square, Merchants & Farmers moved to the North Main Street location shown here late in 1892. (DHCC.)

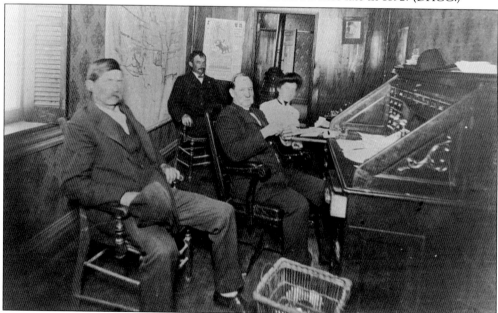

W.H. Eddleman is pictured at his desk at Merchants & Farmers National Bank. Hays McFarland is seated in the back. By 1904, Eddleman had acquired interests in 29 banks in West Texas and Oklahoma, including the Western National Bank in Fort Worth. A local newspaper reported that the Eddlemans purchased 1110 Penn Street from the Ball estate in December 1904 for $32,500. The couple sold their 1887 Weatherford residence in December 1905 for $7,000. (DHCC.)

Bride and Bridegroom

Man's love is of man's life a thing apart,
'Tis woman's whole existence.

Byron.

Carrie Eddleman met Frank Hays McFarland in Nashville in December 1894. When McFarland asked her father for Carrie's hand, W.H. Eddleman extracted a promise that Hays would never take Carrie away from her parents. The couple wed on June 29, 1898, in the Weatherford Eddleman home. A small but distinguished group of guests attended, including Congressman S.W.T. Lanham and the groom's brother Charles McFarland and his wife, Eloise. The bride recorded details of her wedding in a dainty embroidered cloth album. Gifts included a silver tea service, brass bed, chiffonier, French dressing table, $500 check, and a souvenir spoon. This album page features portraits of the bride and groom. The newlyweds set up residence in the Eddleman household, an arrangement that endured both in Weatherford and Fort Worth until W.H. Eddleman's death in 1932. (HFW.)

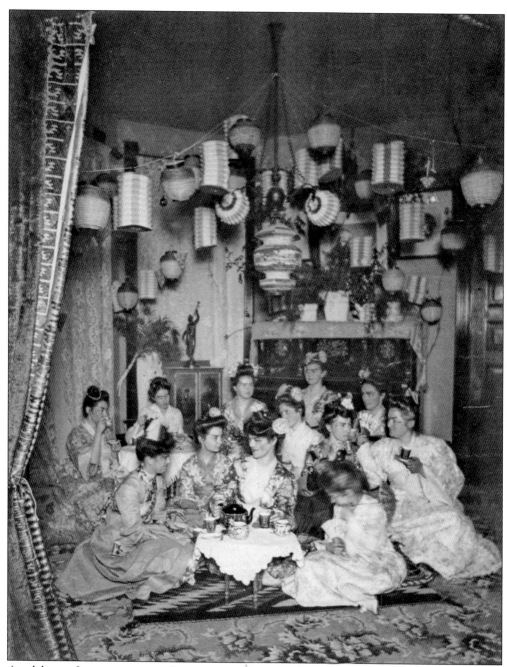

An elaborate Japanese tea party featuring paper lanterns, kimonos, elaborate hairdos, and makeup was an exciting trend at the turn of the 20th century. This party was given by Carrie McFarland around 1904 at her Weatherford home. The sculpture in the background is entitled *Aurora* and was given by Hays McFarland to his bride as a wedding gift. It is part of the permanent collection at the Ball-Eddleman-McFarland House. (CC.)

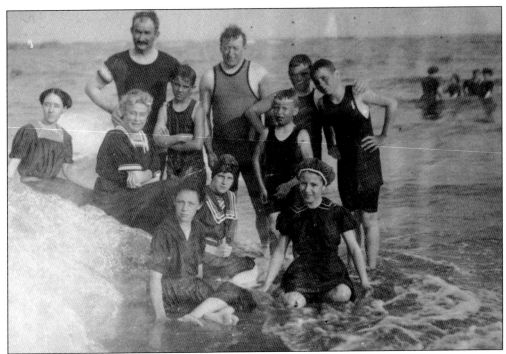

Hays and Carrie McFarland often traveled to the East Coast for the summer, staying first at Swampscott, Massachusetts, and later at Wentworth by the Sea in New Castle, New Hampshire. During these summer excursions, Carrie McFarland acquired many fine pieces of antique furniture to decorate her Penn Street home. The above photograph depicts the couple (rear left) early in their marriage in swimming attire at the beach, location and companions unidentified. The McFarlands are pictured below in the front of the middle row of seats on a tour bus in Washington, DC, in March 1912. The purpose of their trip to the nation's capital is unknown. (Both, HFW.)

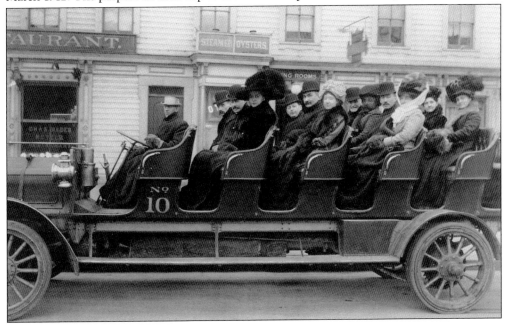

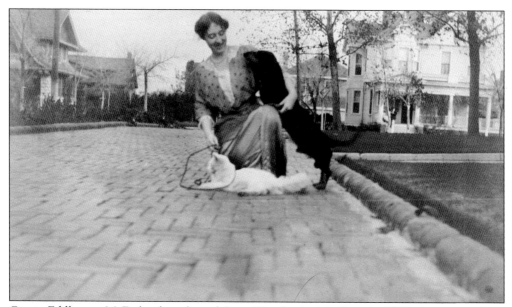

Carrie Eddleman McFarland graduated from Weatherford College in 1895. As a young Fort Worth matron, she was active in many civic endeavors, including the Assembly, of which she was a charter member in 1912 and president in 1918. She is pictured on the red brick driveway of her Fort Worth home with her furry friends. Visible behind her are the neighboring Penn Street homes of J.B. Googins (left) and Wharton Davenport. (HFW.)

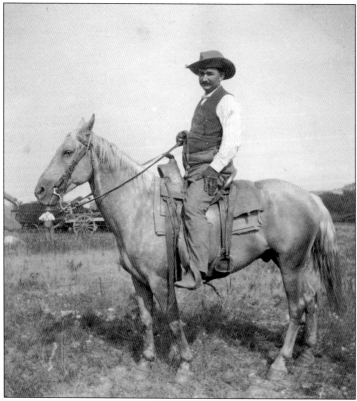

Frank Hays McFarland, a Tennessee native, earned law degrees at Cumberland and Yale Universities. Following his marriage to Carrie Eddleman, McFarland became affiliated with many Eddleman business interests and partnered with his brother Charles in a Weatherford cottonseed warehouse and ranching endeavors. In the 1920s, Hays McFarland was said to have the finest herd of polled Herefords in the state of Texas. He is seen here on horseback, perhaps on the family's Parker County ranch. (HFW.)

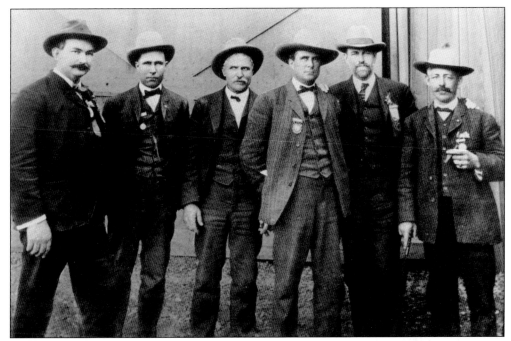

The Fort Worth Fat Stock Show began in 1896 at the suggestion of Charles McFarland, brother of Hays McFarland. Now the Southwestern Exposition and Livestock Show, it is still a popular local event and has contributed to Fort Worth's notoriety as "Cowtown." Pictured here are, from left to right, Hays McFarland, Babe Woodhouse, Ben Woodhouse, Sonny Fain, E.D. Farmer, and Asa Grant while attending the Fort Worth Stock Show and Rodeo in 1906. (HFW.)

W.H. Eddleman owned thousands of acres of ranch land in Tarrant and Parker Counties. This picnic was held in 1910 or 1911 for his Crowley ranch employees and their families. He is pictured, left of center, holding a silver dollar in his right hand and a cigar in his left hand. In 1902, Eddleman gained title to over 98,000 acres in nine West Texas counties when he purchased the outstanding shares of the Franco-Texan Land Company. (HFW.)

The Ball-Eddleman-McFarland House front parlor (above) was photographed by W.D. Smith during the Christmas season in the 1930s. After the death of her husband in 1948, Carrie McFarland made a number of changes to personalize the house. To brighten the room, she used her beloved pink in both the wallpaper and the new marble fireplace surround. Instead of removing the small painted-glass window above the fireplace, the overmantel was removed and the casement enclosed. Today, the exquisite glass window can only be viewed from the exterior. A group of friends are sitting in the updated parlor in the below photograph, taken between 1948 and 1963. The ladies are Helen Mitchell (left), Mattie Mae Anderson (right), and unidentified. The Junior League of Fort Worth purchased 1110 Penn Street from the McFarland estate in 1979. (Both, HFW.)

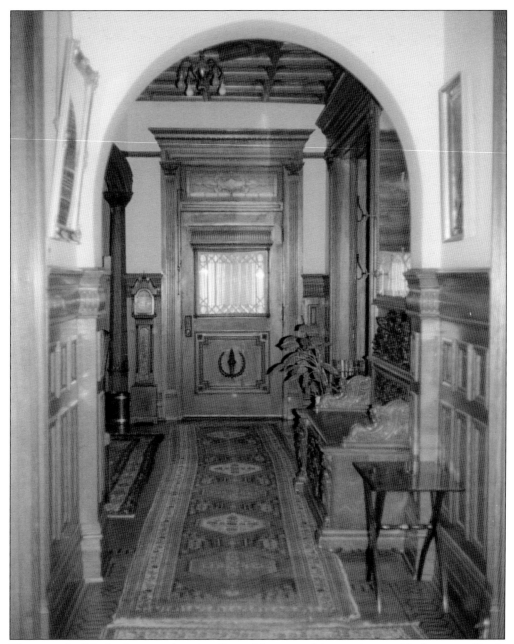

The entry hall is the foremost location for making a good impression on all who enter. Carrie McFarland selected the warm hues of expensive Oriental rugs to complement the oak wainscoting, parquet floor, and coffered ceiling of her entry and central hallways, pictured here in the 1960s. A heavily carved wooden bench, dating to the Eddleman tenure and now returned to the house, can be seen on the right under a mirror. A grandmother clock stands next to the front door. The alcove room, a more casual living space, is just out of view to the left of the leaded-glass front door (see page 42); the formal front parlor is across the entry hall to the right (opposite page). The central hallway opens on to both the back parlor and the dining room. (HFW.)

Although the McFarlands had no children of their own, Carrie McFarland always had a special place in her heart for little ones. In 1917, she and a group of her friends formed what became the Fort Worth Day Nursery, designed to care for children of working mothers. Posing with other day nursery directors on March 5, 1938, are McFarland (first row, second from left) and neighbors Mattie Mae Anderson (second row, second from left) and Ruth Googins (far right). (UTA/FWST.)

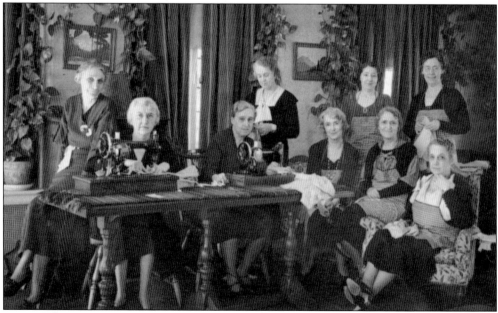

Sarah Eddleman and Carrie McFarland were involved in American Red Cross work, Eddleman during World War I and McFarland in World Wars I and II. Carrie McFarland (standing, second from right) is among the ladies shown here working on a 1940s-era "handwork" project at an unidentified residence. The handwork might have been bandages for soldiers or clothing for children at the Fort Worth Day Nursery. (HFW.)

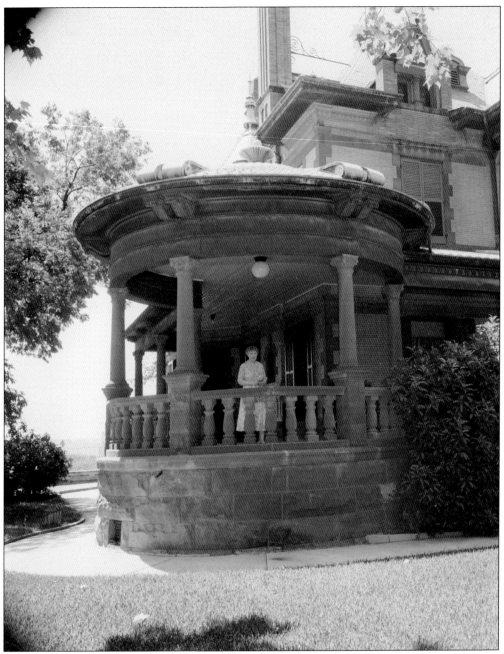

W.H. Eddleman deeded 1110 Penn Street to his daughter after her mother passed away in 1921. Carrie McFarland lost her father in 1932, and her husband died 16 years later, in 1948. Over the years, Quality Hill deteriorated, and her neighbors relocated to up-and-coming, wealthy residential areas in west Fort Worth. Carrie McFarland, pictured here on the distinctive round front porch for a 1958 *Fort Worth Star-Telegram* article, would live in her landmark home until she passed away at the age of 100 in 1978. Her quiet determination to stay in her home despite the changing neighborhood saved her home, and probably the Pollock-Capps home next door, for future generations to enjoy. (UTA/FWST.)

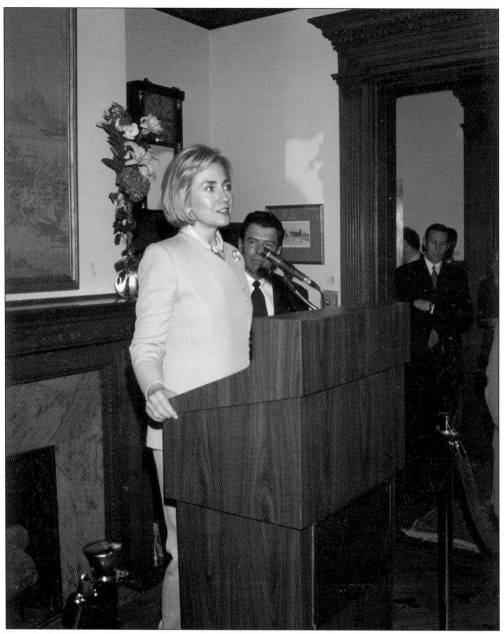

First Lady Hillary Clinton spoke at the Ball-Eddleman-McFarland House in February 1999, a special guest at a birthday party given in honor of Texas General Land Office commissioner Garry Mauro. She addressed the vetted crowd from the back parlor in a powder-blue pantsuit. Mauro is seen here, seated behind Clinton. The former butler's pantry was prepared as a private meeting space for the first lady should she choose to use it. Clinton was not the only first lady to visit Penn Street. Ruth Googins grew up across the street at 1101 Penn Street. She married Elliott Roosevelt in 1933. First Lady Eleanor Roosevelt visited Penn Street to meet her new grandson, David Boynton Roosevelt, born in 1942. (SFP.)

Three

SUMMIT AVENUE

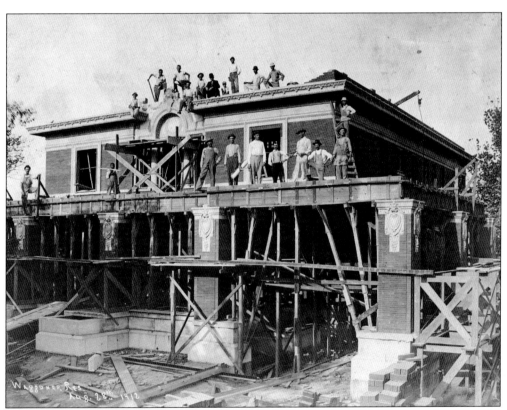

The *Fort Worth Star-Telegram* reported on May 6, 1912, that the W.T. Waggoner home, under construction at 1200 Summit Avenue, would be "the finest residence in Fort Worth when completed." Construction workers posed for this progress photograph on August 28. Contemporary accounts estimated the construction cost to be $100,000; later reports pegged that number at $250,000. The Waggoner homesite extended 700 feet down the bluff toward the Trinity River. (UTA/FWST.)

The Waggoner home, pictured above shortly after its completion in 1913, is said to have had 22-karat gold door fittings, ornate chandeliers, mahogany paneling, a third-floor ballroom, and a basement with a cooling system that forced air over 300-pound blocks of ice. This was not the Waggoners' first Fort Worth residence, nor was it their last. In 1906, the family moved from Decatur to the former J.B. Slaughter home at 556 South Summit Avenue. They built another Georgian mansion in the Rivercrest area in 1923, where Waggoner passed away in 1934. His widow, Ella, later built a home in Westover Hills, where she lived until her death in 1959. Bryan Hanks purchased the Summit property around 1947. The photograph below was taken in February 1965. The home was razed shortly thereafter, ultimately making way for the Summit Towers, constructed in the 1970s. (Both, UTA/FWST.)

W.T. Waggoner (right) was a Wise County cattleman with vast ranch lands and cattle herds. In 1909, he gave each of his three children 90,000 acres of land and 10,000 head of cattle. Drilling for water, he discovered oil. Waggoner established his own refineries and marketing system, all bearing the Three D cattle brand, which also appeared on the silks of his Three D Stock Farm Racing Stables. Waggoner also had investments in banking, insurance, and downtown Fort Worth real estate. The Waggoner Building (below, at right) was designed by Sanguinet and Staats. Completed by 1920, the 20-story, Chicago-style office building featured modern conveniences, including elevators, a built-in vacuum system, and refrigerated drinking water from its own artesian well. It stayed in the Waggoner family until 1962. (Both, UTA/FWST.)

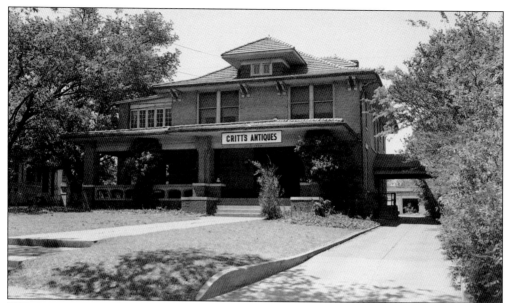

W.T. Waggoner paid $50,000 for the James Harrison residence at 1212 Summit Avenue in May 1913. The house would be occupied by two Waggoner sons. Guy Waggoner and, later, Edward Paul Waggoner and his wife, Helen. E. Paul Waggoner owned the Double Heart Ranch near Vernon and was a director of the First National Bank in Decatur. By 1950, the property at 1212 Summit Avenue had been converted to commercial use as an antiques store. It was demolished in the early 1960s. (UTA/FWST.)

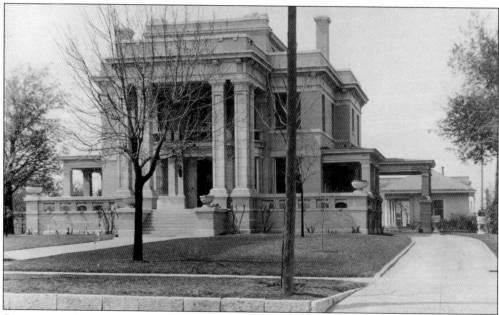

Sanguinet and Staats designed this Neoclassical residence at 1304 Summit Avenue for T.B. Ellison around 1897. Ellison was a cofounder of the Maddox, Ellison & Company furniture business in 1889. Acquiring the majority of the stock in 1905, he moved the business to Seventh and Throckmorton Streets, where it long operated as Ellison's Furniture Company. The Ellison residence was one of several parcels assembled for later commercial use. It was razed in 1965. (UTA/FWST.)

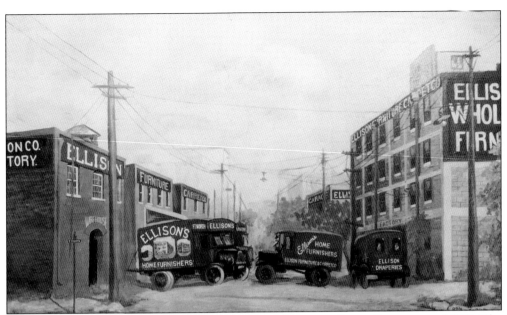

Ellison's Furniture Company constructed three warehouses on Pecan Street around 1911. The two-story buildings were connected by overhead walkways. About 1913, a reinforced-concrete and brick mattress factory (below), thought to have been designed by Sanguinet and Staats, was constructed across Pecan Street for the Ellison firm. The warehouses, mattress factory, and Ellison delivery vehicles are depicted in the above painting by an unnamed artist. In the 1990s, the Ellison buildings on Pecan Street were restored by Scott Tindall, forming the nucleus of a historic warehouse district just east of downtown Fort Worth. (UTA/FWST.)

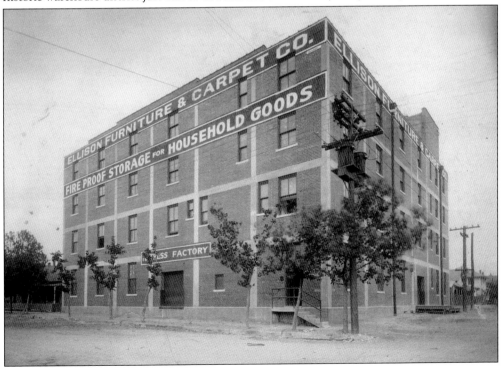

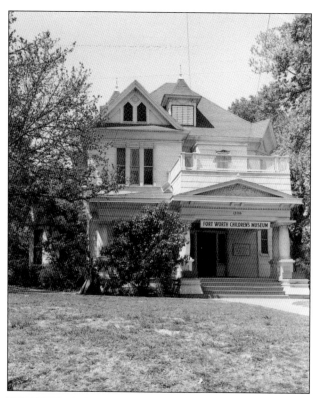

Furniture merchant William T. Fakes sold this three-story white frame residence to Noah Harding in 1889. Harding came to Texas in 1883 and had an affiliation with the banking house of Tidball, Van Zandt & Company. He was the first cashier and later vice president of its successor, Fort Worth National Bank. Harding passed away in 1914. The residence was later used as the Fort Worth Children's Museum (left). Acclaimed Fort Worth artist Evaline Sellors is shown below working with Suzanne Lowry and Travis Coomer during a Children's Museum puppetry class in February 1949. (Both, UTA/FWST.)

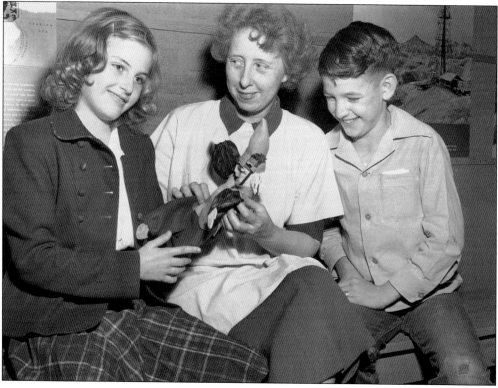

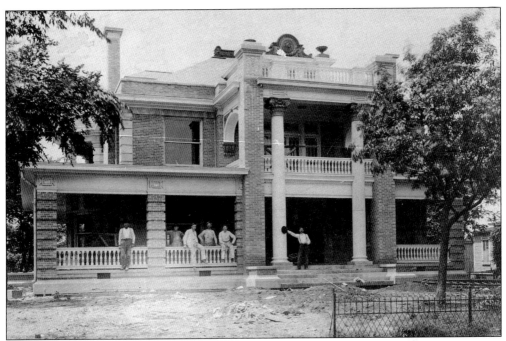

S.B. Burnett sold fellow cattleman James H. Nail a lot measuring 100 feet by 600 feet on Summit Avenue for $12,500 in February 1905. Newspaper accounts reported that the lot was part of the "old Hoxie place" and adjoined the Burnett property on the north. By July 1905, Nail had obtained a building permit for a $20,000 brick-and-stone residence then under construction by Lusher and Rockett. The Neoclassical residence at 1320 Summit Avenue is thought to be a Sanguinet and Staats design. The house, shown under construction in the above photograph, featured light-colored brick and a two-story entry porch accented by two Corinthian columns. Below, Nail is pictured on horseback in front of his Summit Avenue home. In 1909, Nail was named a charter director of Texas State Bank. In 1918, he leased his 54,000-acre ranch in Shackleford County for oil development. (Above, UTA/FWST; below, OJAC.)

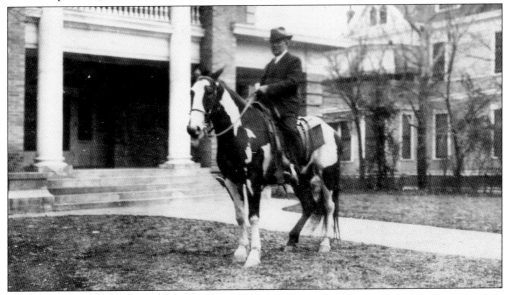

In March 1905, J.T. Pemberton, cashier of the First National Bank of Midland, came to Fort Worth, where he became vice president of Farmers and Mechanics National Bank. In April 1909, he purchased 1326 Summit Avenue from Roy Burnett, who had acquired the home from John C. Phelan in 1907. The two-story, full-facade porch supported by Ionic columns is a striking feature of this frame residence, pictured here in 1950. (UTA/FWST.)

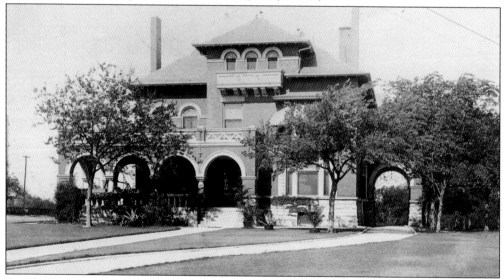

Dr. W.A. Duringer purchased a lot measuring 100 feet by 1,640 feet from Mary Couts Burnett for $12,500 in April 1905. It adjoined the "old Hoxie place" on the south and extended almost to the Trinity River. L.B. Weinman drew the plans for the stone-and-brick residence. The house, at 1402 Summit Avenue, was estimated to cost between $15,000 and $20,000. Additional improvements were to include a private park and a lake behind the house. (UTA/FWST.)

W.A. Duringer, a respected physician and surgeon, came to Fort Worth about 1875. He was president of Fort Worth Medical College for two years and served as chief or general surgeon for several railroads as well as for Armour & Company. A member of several fraternal organizations, Duringer was well known as a fisherman, as indicated by this caricature from *Makers of Fort Worth.* (UTA.)

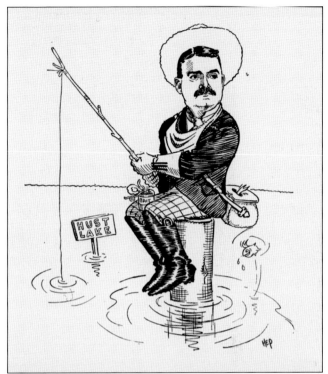

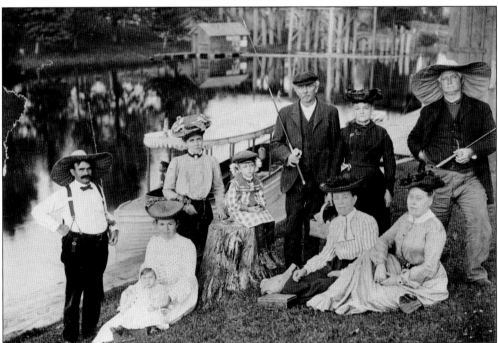

The Duringer and Feild families enjoy a picnic and a day of fishing at Hurst Lake about 1907. Sarah Feild is seated second from right. Also shown here are Dr. W.A. Duringer (far left), Bernice Duringer (fourth from left), Elizabeth Duringer (sitting on tree stump), and Dr. Julian Theodore Feild (center). The remaining individuals are unidentified. (Joseph Minton; UTA/Jack White.)

The Duringer home, at 1402 Summit Avenue, was sold to the A.J. Armstrong family in 1938, the year following Dr. Duringer's death. From 1952 to 1958, it was the home of the Reeder School, a children's theater school under the direction of Dickson and Flora Reeder. A play was selected for the students, aged four to fourteen, to perform in the spring. In addition, students were immersed in the history, art, dance, literature, and music of the period. The Reeders engaged fellow members of the Fort Worth Circle of artists, including Bill Bomar, Lia Cuilty, Cynthia Brants, and Bror Utter, to paint props, make costumes, and construct sets. Students are pictured above in class. At left, students perform in the 1958 production of *Nala and Damayanti*, staged at the Community Theater Play House on Sylvania. The All Church Home purchased 1402 Summit Avenue in 1961. (Both, LAP; UTA/Reeder.)

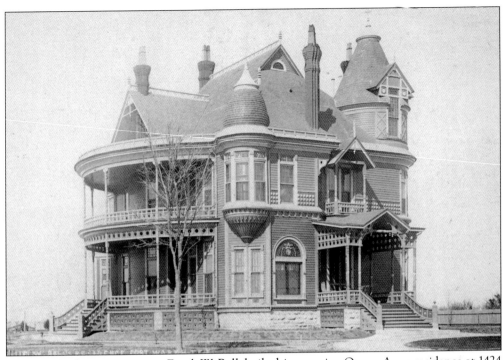

Fort Worth's first city attorney, Frank W. Ball, built this stunning Queen Anne residence at 1424 Summit Avenue in the late 19th century. The exterior photograph of the house (above) was taken by Swartz Brothers, revered Fort Worth photographers. Of frame construction, the home's design reflected favored Victorian elements of the day, including asymmetrical elevations and turrets. Large semicircular porches protected the south facade from the hot summer sun. The light-studded "wicker style" parlor of the Frank W. Ball residence at 324 Summit Avenue (below) was photographed in 1895. Perhaps a different location, the 324 Summit Avenue address is thought to be an earlier street number for 1424 Summit Avenue. Ball, a highly regarded attorney, retired to his ranch near Canadian, Texas, in 1899. He died in 1900 at the young age of 54. (Both, FWPL.)

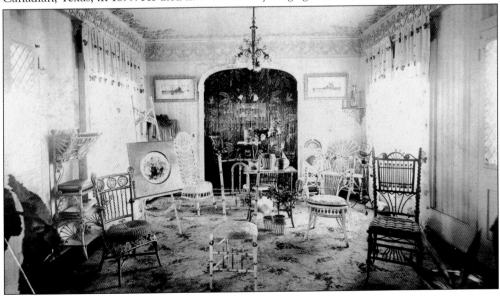

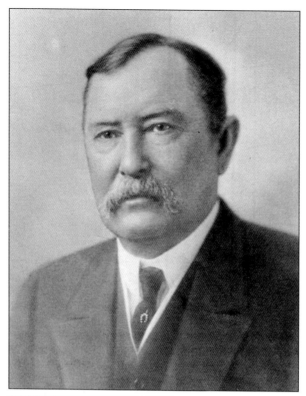

Samuel Burk Burnett began his vast cattle empire at age 19 with the purchase of 100 head of cattle branded "6666." He was one of the first Texas ranchers to buy and graze steers for market. When asked, Burnett would say he was a cattleman, but he was also known for ranching, banking, business, and oil endeavors. As of 1900, Burnett maintained a residence in Fort Worth, the headquarters of his financial enterprises. He acquired the Ball property at 1424 Summit Avenue for his family, second wife, Mary Couts Burnett, and son Burk Burnett Jr. The fate of the former Ball residence is a matter of speculation. It appears that Burnett remodeled it, as some elements of the new structure (below)—its general footprint, entrance location, rounded tower rooms, and south-facing porches—are reminiscent of the older Ball home. (Left, UTA; below, AM.)

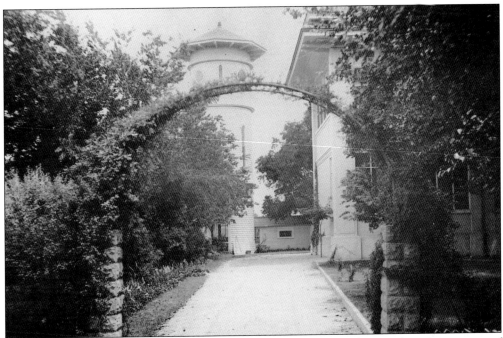

The striking stone archway shown above framed the driveway leading to the side entrance of the Burnett residence, its servants' quarters, and the water tower extant from the Ball tenure. The back yard of the house featured a vine-covered pergola (below) that sheltered its occupants from the Texas sun or the occasional rain shower. Garden parties would have been a favorite entertainment for neighbors and guests. Other improvements to the Burnett property included a tennis court, laid out in March 1907 in conjunction with the revival of the Fort Worth Tennis Club. (Both, AM.)

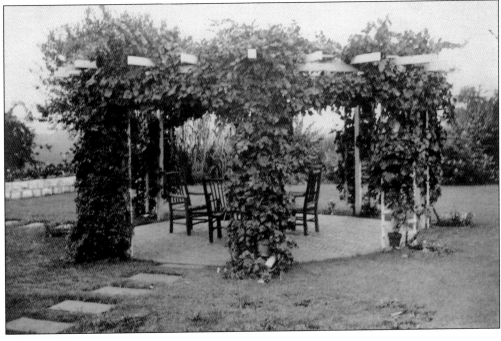

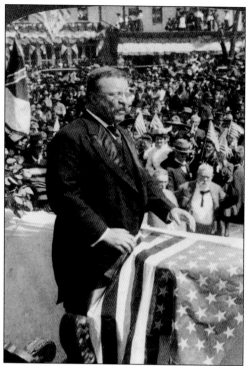

Assisted by Comanche chief Quanah Parker, Burnett leased 300,000 acres of Kiowa and Comanche land in Indian Territory for grazing. Asked to surrender his lease to open Oklahoma land to homesteaders, Burnett traveled to Washington, DC, where he petitioned Pres. Theodore Roosevelt for an extension. Roosevelt granted the request, allowing Burnett time to purchase vast ranch lands in Carson and King Counties. Roosevelt visited Fort Worth in 1905, as shown at left in the photograph taken by C.L. Swartz. The president then participated in a Burnett-hosted coyote/wolf hunt. Burnett maintained long-term friendships with both Parker and Roosevelt. In 1917, Burnett commissioned Sanguinet and Staats to design a $100,000, 11-bedroom Guthrie ranch headquarters home (below). It was built from stone quarried on the ranch. Furnished with hunting trophies and personal gifts from Quanah Parker, Burnett entertained luminaries such as Will Rogers and Theodore Roosevelt in grand style. (Both, UTA/FWST.)

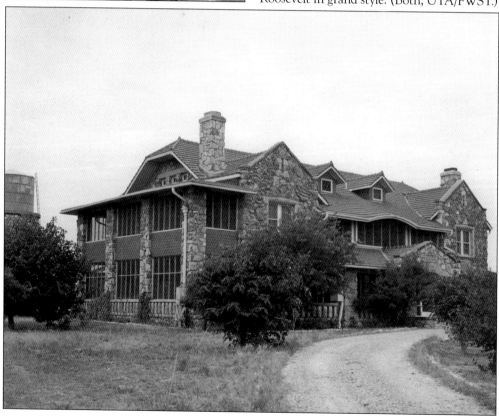

In early 1915, Burk Burnett paid cash for the recently completed State National Bank Building at Fourth and Main Streets, giving it his own name. Designed by Sanguinet and Staats, the Neoclassical office building was said to be the tallest and most modern in the city when it opened. Oil was discovered on the Burnett ranch lands in 1921, greatly adding to Burnett's fortunes. He was also director and principal stockholder of First National Bank, a founder of the Texas and Southwestern Cattle Raisers Association, and first president of Southwestern Exposition and Fat Stock Show. His estate was valued at $6 million upon his death in 1922. The All Church Home, a residence for underprivileged children, acquired 1424 Summit Avenue and its 12 acres of grounds from the Mary Couts Burnett Trust in 1936. It is shown below in a slide dated 1960. (Right, Acme Brick; below, BLL.)

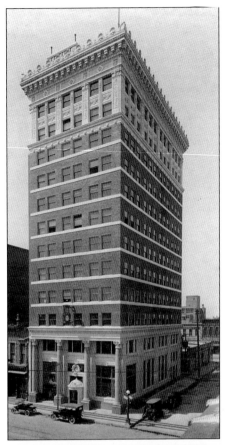

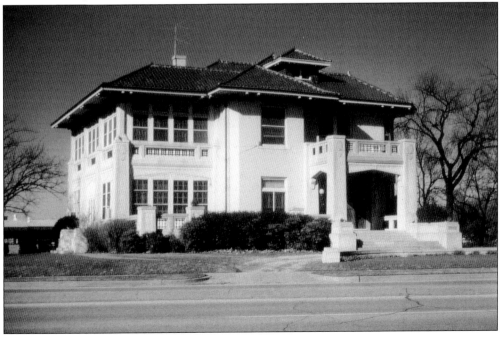

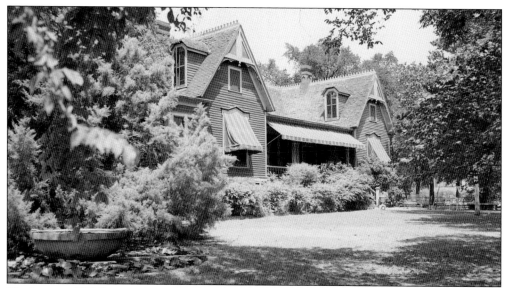

The home at 1502 Summit Avenue is thought to have been built for cattleman and banker Ephraim B. Harrold about 1883. Harrold moved to Fort Worth to become the cashier for First National Bank, concluding a seven-year partnership with his brothers in the cattle business in Archer County. He also helped organize the Fort Worth Light & Power Company in 1885 and was one of the owners of the Scott-Harrold building on Main, Houston, and Fifth Streets. His family continued to occupy the house after his death in 1911. His daughter Mrs. M.M. Barnes left the residence and lot to the City of Fort Worth for park purposes when she passed away in 1947. These photographs of the house and her library, containing 5,000 books bequeathed to Fort Worth Children's Hospital, appeared in the *Fort Worth Star-Telegram* in August 1947. (Both, UTA/FWST.)

In September 1867, young William D. Reynolds began working as a cowboy for Charles Goodnight and Oliver Loving on a cattle drive to Colorado. It was on this journey that Loving was killed by Indians. Reynolds led the party that returned Loving's body to Weatherford for burial, a story loosely chronicled in Larry McMurtry's *Lonesome Dove*. In 1868, Reynolds (right) and his brother George formed Reynolds Land & Cattle Company and adopted the Long X as their brand. The company acquired vast ranch lands in Shackelford, Throckmorton, and Haskell Counties and was incorporated in Albany in 1884. In 1895, the Reynolds brothers bought some 232,000 acres of land in Jeff Davis County, including the Rockpile Ranch and the Long X Ranch (below). Their last major cattle drive occurred in 1902, the same year the company name changed to Reynolds Cattle Company. (Right, UTA; below UTA/FWST.)

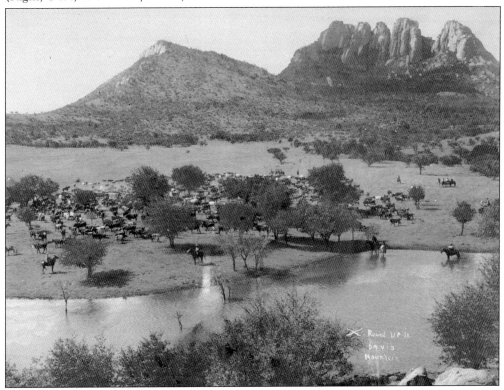

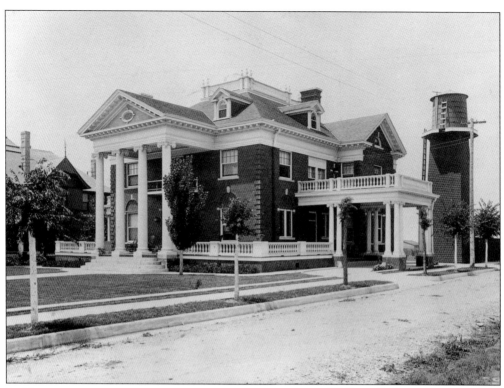

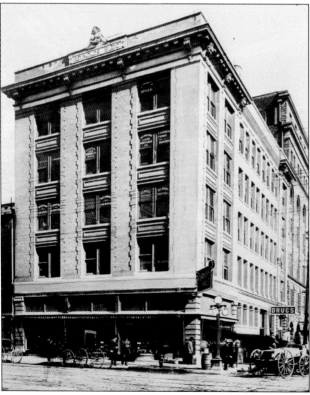

William D. Reynolds purchased the residence above at 1600 Summit Avenue while it was under construction. The Reynolds family, including eight children, moved into the house in 1902. Located on the southwest corner of Summit Avenue and Jarvis Street, the red brick Neoclassical home featured corner quoins, a full-height entry porch supported by Ionic columns, and a low balustrade around its platform porch. This Charles L. Swartz photograph provides an excellent view of the porte cochere and water tower behind the house. Brother George Reynolds built a neighboring home at 1404 El Paso Street. The Reynolds brothers owned several commercial buildings in downtown Fort Worth, including a structure at Eighth and Houston Streets (left). (Above, UTA/Jack White; left, UTA/FWST.)

Four

OTHER NORTHSIDE STREETS

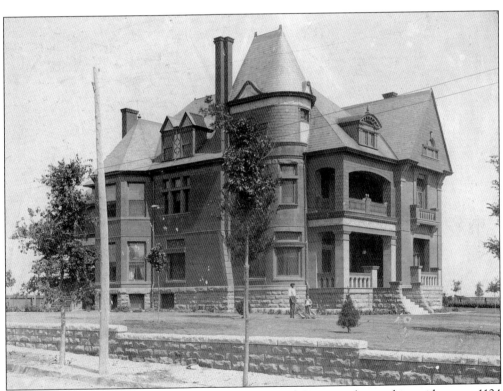

Attorney Hyde Jennings commissioned Sanguinet and Staats to design this residence at 1124 Lake Street, on the northwest corner of North Street (now Lancaster Avenue) and Lake Street. The architectural firm featured the Jennings home in its 1896 brochure. Jennings was married to the former Florence Van Zandt, daughter of K.M. Van Zandt. This photograph of the house is dated 1894. (FWPL.)

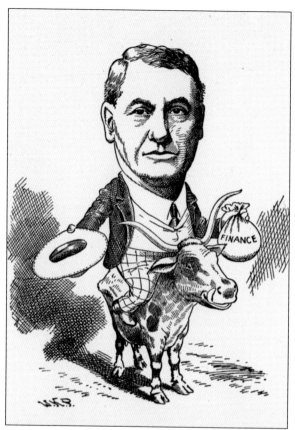

Cattleman Sam Davidson purchased the Jennings residence at 1124 Lake Street in March 1897 for about $30,000. Davidson's business interests included Crystal Ice Company; a franchise to provide Fort Worth with gas, steam heat, and electric power; a cotton mill; and the Texas Chevrolet Company. This caricature from *Makers of Fort Worth* depicts his roots in both cattle and finance. Davidson was politically active. As city commissioner, he was responsible for instituting the Kessler plan for city parks. He was also a candidate for Fort Worth mayor and Texas lieutenant governor. In 1910, Pres. William Howard Taft appointed Davidson as a census supervisor. His civic endeavors included membership in the Shriners, Elks Club, River Crest Country Club, and Texas and Southwestern Cattle Raisers Association. In 1916, he was elected president of the Temple Beth-El congregation. His home is shown below as pictured in the 1902 Cattle Raisers program. (Left, UTA; below, JG.)

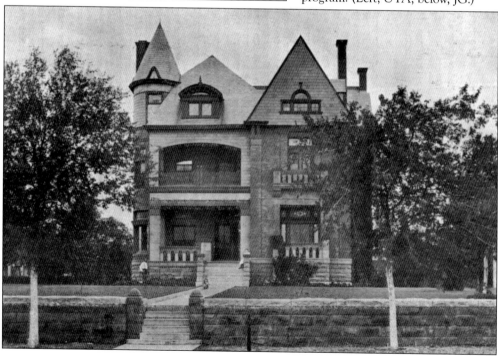

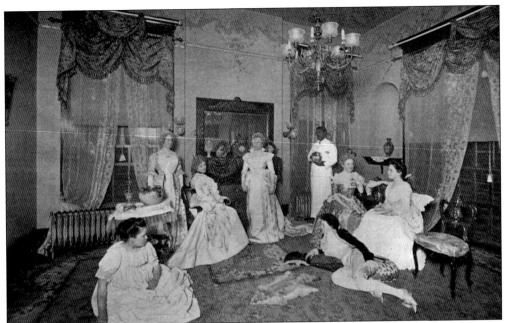

Featured in the Easter 1900 edition of the *Bohemian*, the Sam Davidson residence was touted as "a model of convenience and modern appliances." The Davidson drawing room (above) and dining room (below) are pictured during "one of the most noted fetes ever given in the city." The party had a Colonial theme, and guests wore period dress and powdered wigs. The dining room was decorated with a complementary patriotic decor, including American flags and an abundance of palms and other greenery. The festive mood would not be long lived, as the Davidsons' eight-year-old son, Frank, died in February 1901. The neighborhood was already in transition when James Harrison donated temporary use of the residence to the War Service Board to house soldiers in 1918. (Both, UTA.)

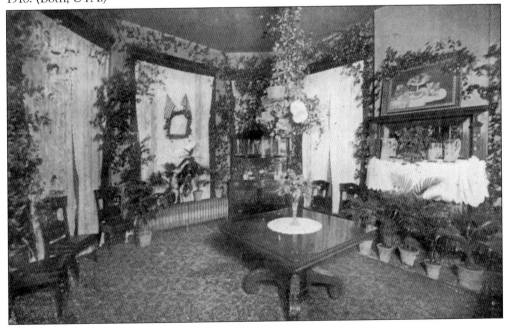

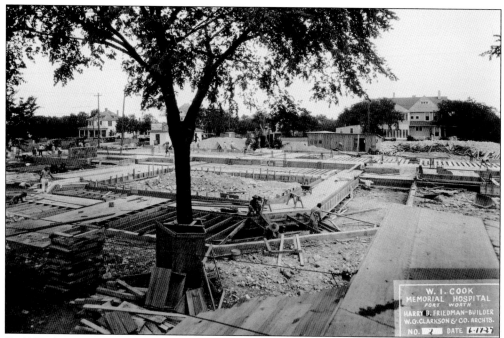

By 1927, the Jennings-Davidson residence made way for the new W.I. Cook Memorial Hospital at 1212 Lancaster Avenue. Matilda Nail Cook provided the funds to build this general hospital in memory of her husband and daughter, with the intent that services would be offered to patients regardless of their ability to pay. Said to be one of the finest hospitals of its size in the nation, Cook Hospital was completed in 1929. The project was designed by Wiley J. Clarkson and built by Harry B. Friedman, a team that would soon collaborate again on the neighboring Masonic temple. The hospital's eclectic architectural design incorporated Indiana limestone, Italian travertine, green terra-cotta roof tiles, and heavy bronze doors. The Jernigan Photo Service documented the construction of Cook Hospital from beginning to end. (Both, UTA/Friedman Construction.)

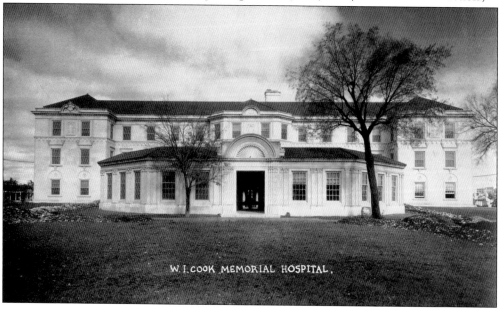

Hyde Jennings was the son of Thomas Jefferson Jennings, a former Texas attorney general and state legislator. He followed his father's footsteps in the legal profession and moved to Fort Worth about 1872 to manage the extensive real estate holdings belonging to his mother, Sarah Hyde Jennings. Having sold his residence at 1124 Lake Street to Sam Davidson, Hyde Jennings obtained a building permit for a new, $8,000 residence in the Jennings Addition in September 1897. The frame house at the northeast corner of Summit Avenue and North Street (later Lancaster Avenue) is shown below, under construction in 1898. A sign on the second-floor balcony reads "A.N. Dawson Architect." The bicycle probably belonged to photographer Charles Swartz, known for biking around the city with his camera on his shoulder. (Right, Sam Denny family; below, UTA/FWST.)

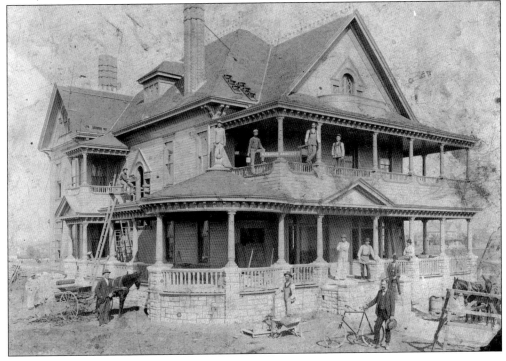

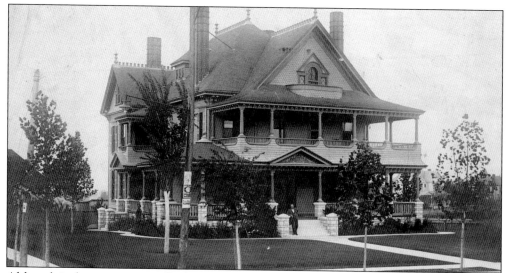

Although its location was usually described as the corner of Summit Avenue and North Street, the street address of the new Jennings residence was 1414 North Street (later Lancaster Avenue). Charles Swartz photographed the Jennings residence a second time (above) in 1898, shortly after the home was ~~completed~~. Hyde Jennings himself may be the man standing at the front steps. With its verdant grass lawn, abundant shade trees, and extensive porches, the home seems to beckon the visitor to pause for a pleasant respite from the summer heat. In September 1947, the *Fort Worth Star-Telegram* documented preparations to dismantle and move the house to the Sycamore Heights Addition. The elegant mahogany stairway (below) curved up to the second floor, with its five bedrooms and ballroom. It was said that many Fort Worth society brides descended this stairway during their weddings. (Above, FWPL; below, UTA/FWST.)

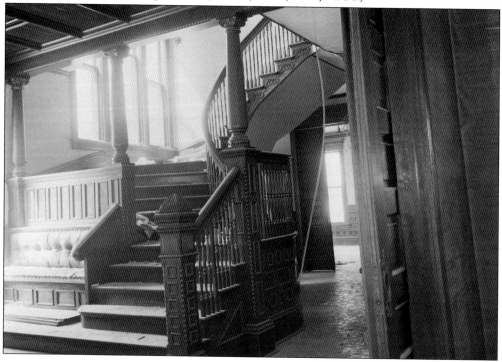

These *Star-Telegram* photographs provide a glimpse of the former elegance of a home once filled with activity, now fallen silent. In the bedroom (right), heavily carved griffins dominate the design of the mirrored fireplace overmantel. A chandelier is visible in the upper right. An office building for Foster Insurance was constructed on this prime corner property after the residential structure was removed. The office building, too, has long since been torn down. The James L. West Center is now located on the site of the Hyde Jennings residence. (Both, UTA/FWST.)

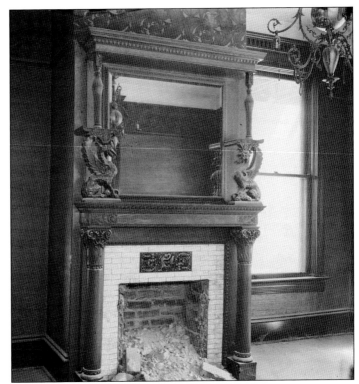

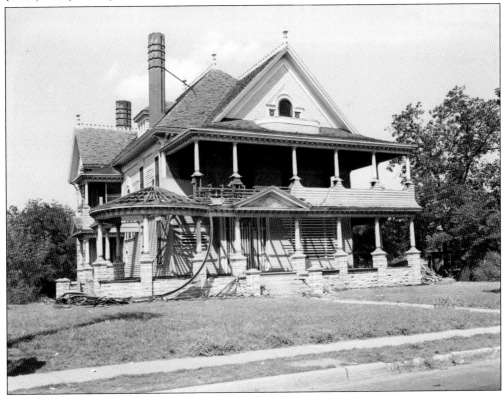

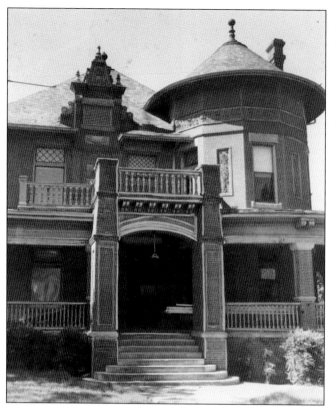

Col. Robert Dickie Hunter built this residence at 1418 El Paso Street and lived there until his death in 1902. Born in Scotland in 1833, Hunter came to Texas in 1887. In 1899, Hunter was president of Texas and Pacific Coal Company, Texas and Pacific Mercantile & Manufacturing, Green & Hunter Brick Company, and Hunter-Phelan Savings & Trust. Cattleman Dan Waggoner, father of W.T. Waggoner, acquired the property after Hunter's death. (UTA/FWST.)

The residence and carriage house located at 1404 El Paso Street were built in 1901 for George T. Reynolds, a principal in the Reynolds Cattle Company of Albany, Texas. The rectangular, red brick home, pictured here in 1960, had projecting bays and a full porch. It remained in the Reynolds family until 1935 and was subsequently used for offices. Vacant and in poor condition, the house was demolished in 1992, and the site is now a parking lot. (BLL.)

Census records indicate that banker James Harrison occupied 1212 Ballinger Street from at least 1900 through 1910. Thomas F. Mastin Sr. retired as president of the First National Bank in Grandview, Texas, in 1910. He and his wife, Mazie, then moved to Fort Worth and acquired the Ballinger Street home from Harrison, who was moving his family to the former Capps residence at 1212 Summit Avenue. Mazie Mastin was the daughter of William Bate, a former governor and US senator from Tennessee. Their son Thomas F. Mastin Jr. became the first DeSoto automobile dealer in Texas in 1928. Beginning in 1932, he was a partner in the Mastin-Parris Motor Company, which long operated at 1012 Seventh Street. These two photographs of 1212 Ballinger Street during the Mastin tenure reveal the house to be a most comfortable abode on a shady, tree-lined street. (Both, LC.)

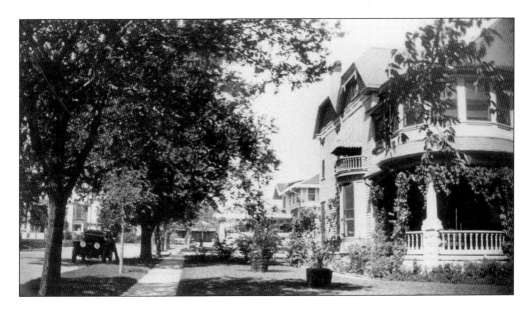

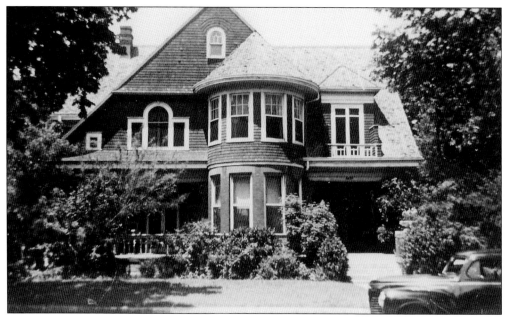

Businessman R.H. McNatt constructed this brick and shingle residence with granite accents at 1302 West Presidio Street in 1901. The McNatt family moved to a ranch in Montague County in 1915. Banker James Harrison occupied the house in 1918. Missouri native O.V. Colvin moved to Fort Worth in 1900 and purchased the house at 1302 Presidio Street in 1925. (ACG.)

O.V. Colvin's meat and grocery business was located at 1606 Main Street for 17 years, then moved to 1210 Houston Street. Colvin married Adelaide Polsgrove in 1898, and they had four children: George H. Colvin II (standing, far right), Marjorie, Mildred (seated), and Virginia. Adelaide Colvin and her children continued to live at 1302 Presidio after her husband's death in 1927. The property was sold in 1951 and razed to make way for medical offices. (ACG.)

Five

PENNSYLVANIA AVENUE

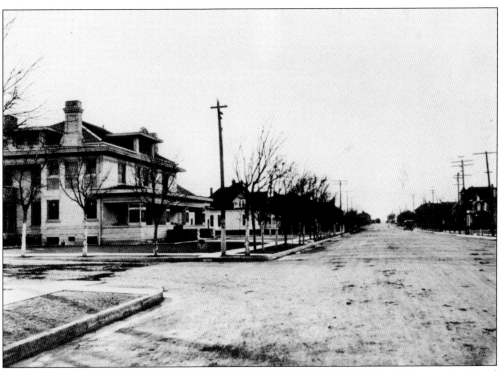

Extending west into the distance from the intersection with Henderson Street, tree-lined Pennsylvania Avenue was a budding residential district with impressive homes constructed by wealthy and socially prominent cattlemen and entrepreneurs. The first home on the left, 1251 Pennsylvania Avenue, was the residence of cotton broker Neil P. Anderson. He purchased the property in the Sandige Addition in 1904. (UTA/McGar/WD Smith.)

Real estate broker W.L. Ligon (left) lived with his family in a frame home at 1221 Pennsylvania Avenue (below). In 1897, W.L. Ligon & Co. merged with C.L. Dickinson & Co., forming Ligon, Dickinson & Co. The firm brokered major real estate transactions, including John B. Slaughter's purchase of a residential lot on Hill Street and Pennsylvania Avenue from Hyde Jennings in June 1897. Ligon and partners purchased 520 lots in the Fairmount and Dissel Additions in the southwest part of the city in 1904. These photographs were published in the 1904 World's Fair edition of the *Bohemian*, a quarterly literary publication in Fort Worth. Captions described Ligon as the chairman of the Board of Equalization and stated that the fence surrounding his home was manufactured by Texas Anchor Fence Co. (Both, UTA.)

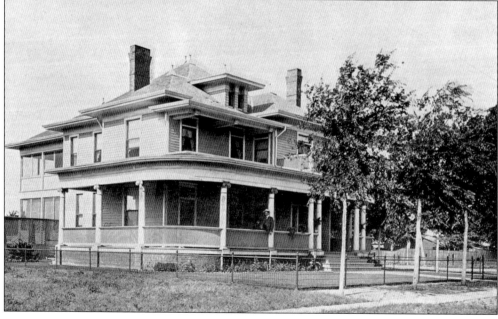

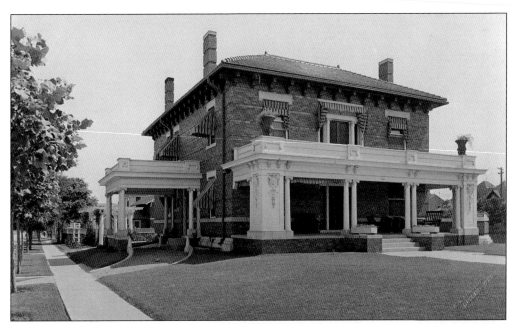

Architect Louis B. Weinman is credited with the design of this rusticated ochre-brick residence built for Emory Thayer Ambler around 1907. Ionic columns supported the full front porch and the porte cochere. The hip roof was sheathed with green glazed tile. Charles Erwin Arnold was commissioned by Acme Brick Company to document the project shortly after its completion. The above photograph clearly depicts the walled terrace that once extended over the front porch, accessed through a second-floor doorway framed with columns. Striped awnings shielded the windows from the Texas sun. Gordon Boswell purchased the house in 1926 and later built a flower shop next door. The house is extant today, although greatly altered in appearance. The portrait of E.T. Ambler (right) is from the 1914 book *Makers of Fort Worth*. (Above, Acme Brick; right, UTA.)

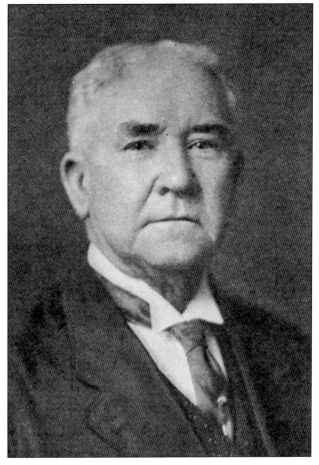

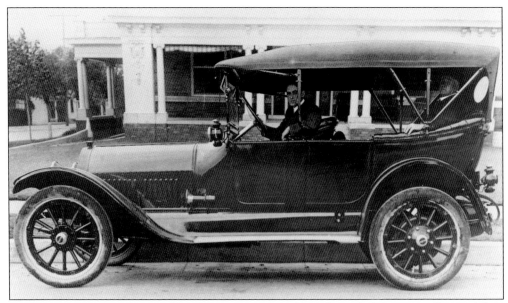

A Connecticut native, E.T. Ambler came to Texas in 1878 and traveled the state selling saddlery and hardware. He was associated with Glidden Wire Company at a time when the Western ranges were being fenced. From 1886 to 1896, Ambler was western manager for the Oliver and Roberts Wire Company. He sold stock he had accumulated in Consolidated Steel and bought a large ranch in Lynn and Garza Counties with C.O. Edwards and John Lofton. C.W. Post purchased Ambler's land and cattle holdings in 1906. Ambler then moved his family to Fort Worth, where he had business interests in real estate investments. Ambler is pictured above in the back of his chauffeur-driven automobile. Below, he and daughter Grace sit atop mules in Mineral Wells. Grace would marry Sam B. Cantey Jr. in a June 1913 society wedding. (Both, Cantey family; UTA/Jack White.)

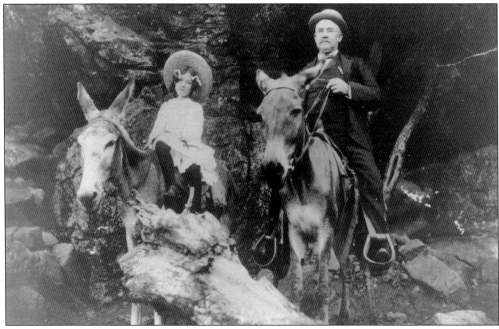

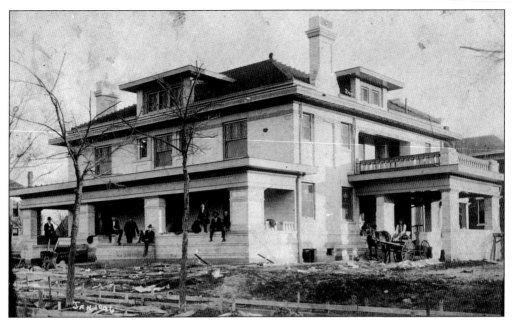

Neil and Elizabeth Anderson called their home Lingerlonger. The November, 19, 1906, *Fort Worth Telegram* society column reported the Andersons entertaining over 90 guests for a candlelit barbeque in the basement of their new home. The menu featured chicken, lamb, pickles, rolls, baked sweet potatoes, and pumpkin pie. The home is seen here nearing completion in January 1906. (UTA/FWST.)

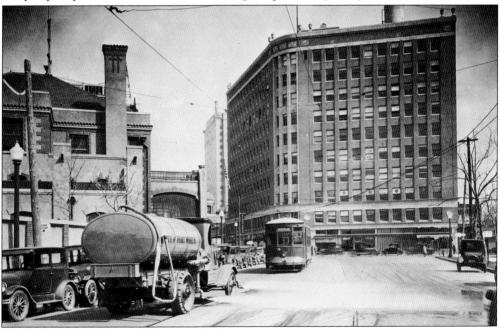

Neil P. Anderson died in February 1912 from injuries sustained in an automobile collision with the Summit Avenue streetcar No. 228. In 1919, in his memory, Anderson's sons began construction of this building, designed by Sanguinet and Staats. The 11-story structure, of concrete and terracotta, is located at Seventh and Lamar Streets. The Neil P. Anderson cotton brokerage moved its offices and sample rooms to the new building when it opened in 1920. (UTA/FWST.)

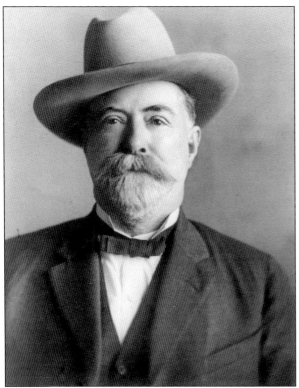

George L. Gause arrived in Fort Worth in 1870, briefly practiced law, then operated a livery stable from 1876 to 1893. In 1879, Gause became the city's first undertaker. His establishment was located originally on Rusk Street, and later in the Gause Block on Weatherford Street. In partnership with his son-in-law John Morton Ware, Gause purchased the Anderson residence at 1251 Pennsylvania Avenue in 1922 and relocated the funeral business in February 1923. (UTA/Gause-Ware Papers.)

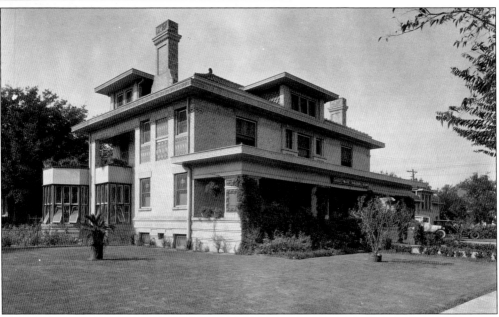

Located on a full half-block in one of Fort Worth's most "charming residential districts," according to *Let There Be Light*, a brochure published by the new venture in 1923, the Gause-Ware Funeral Home site featured green grass, hedges, and flowers. The former Anderson residence, two stories tall with a basement, was constructed of buff brick, brown stone trim, and a tile roof. This view of the funeral home is similar to one in *Let There Be Light*. (UTA/Gause-Ware.)

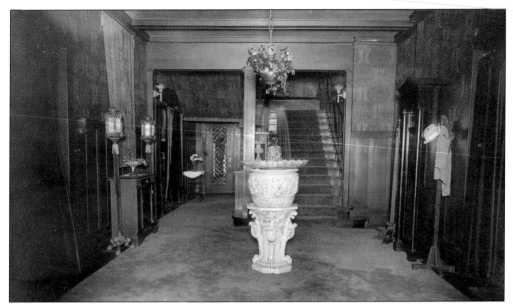

Gause-Ware succeeded in its desire to make the bereaved feel as though they were walking into the "well-appointed mansion of a wealthy businessman" according to *Let There Be Light*, which provides a view of the interior of 1251 Pennsylvania Avenue during the Anderson tenure. The reception hall (pictured) gave visitors a positive first impression. Finished in quarter-sawed oak with a beamed ceiling, the room featured a fountain. Its soothing water sprays offered comfort and calm. (UTA/Gause-Ware.)

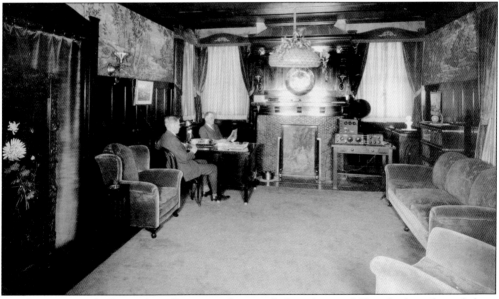

Off the reception hall was the office, its mahogany desk and several filing baskets the only hint that business was conducted therein. The room featured mahogany wainscoting and a heavy-beamed ceiling. The walls were covered with imported tapestries depicting woodland scenes. A large radio set and fireplace were located at one end of the room. *Let There Be Light* remarked that "service to humanity ever takes precedence over business considerations at the Gause-Ware Funeral Home." (UTA/Gause-Ware.)

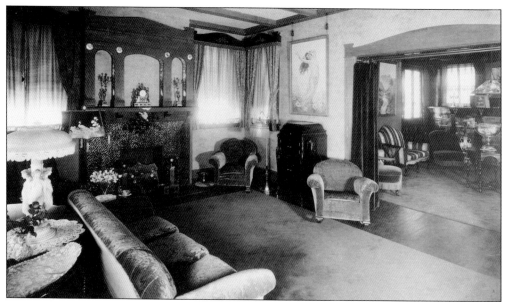

To the left of the reception hall were two connecting funeral parlors. Heavy chenille carpets quieted footsteps, and silk velour draperies and tapestries adorned the walls. Softly illuminated lighting bathed the overstuffed furniture. A Victrola with appropriate, carefully selected recordings and a piano provided music for these spaces. The two parlors offered "an atmosphere of peace and beauty, minus the inevitable disturbance and inconvenience attendant upon funerals held at private homes," as reported in *Let There Be Light*. (UTA/Gause-Ware.)

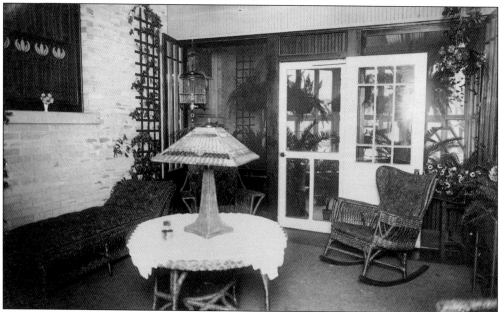

A door at the rear of the reception hall led to the sunroom and conservatory. The buff brick walls with coordinating carpet and ceiling provided a space filled with light and warmth. Upholstered wicker furniture and airy windows added to a feeling of quiet repose. Cheerful canaries serenaded those seeking refuge there. The adjoining conservatory contained ferns, palms, and blooming plants, which were available to be used around the casket. (UTA/Gause-Ware.)

The prepared body was moved to the slumber room, where it reposed on a daybed until placed in a casket and moved to the funeral parlor. Here, relatives and friends could spend their last moments with the deceased in privacy, quiet, and comfort. A dainty pink bassinet was provided for infants. A large built-in refrigerator was available for flowers, and a built-in vault could be used to store valuables. (UTA/Gause-Ware.)

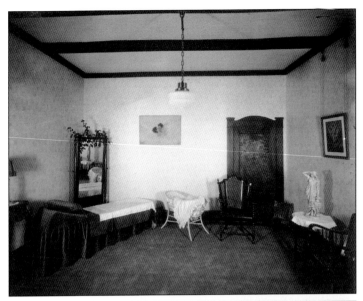

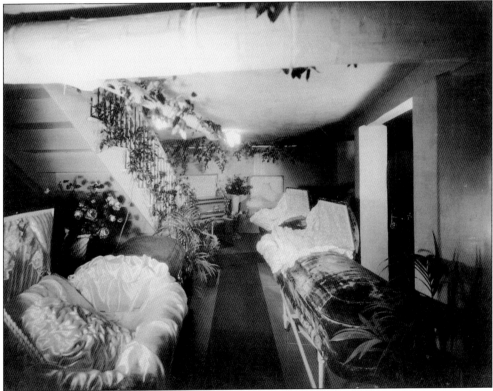

There were two casket display rooms in the basement of the home. Jardinieres containing fragrant blooming flowers decorated the rows of caskets. The offerings ranged from the most luxurious and elaborate to those of modest construction. They were made of a variety of materials, including steel, bronze, and cypress; metallic-lined California redwood; and woods such as walnut, oak, cedar, and mahogany. These spaces provided a setting of beauty whereby a casket could be selected to meet individual needs. (UTA/Gause-Ware.)

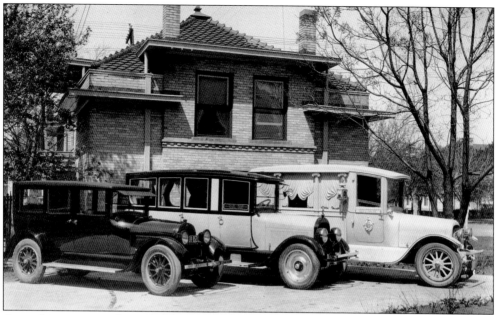

A matching garage at the rear of the grounds housed the motor equipment and second-floor living quarters for around-the-clock attendants. Included were two hearses of the latest design, and safe and easy-riding ambulances equipped with a heater, electric fan, thermos bottles, first-aid kits, baby basket, and lung motor. Cadillac limousines were used as family cars. A concrete driveway wound through the porte cochere and exited on to Pennsylvania Avenue. (UTA/Gause-Ware.)

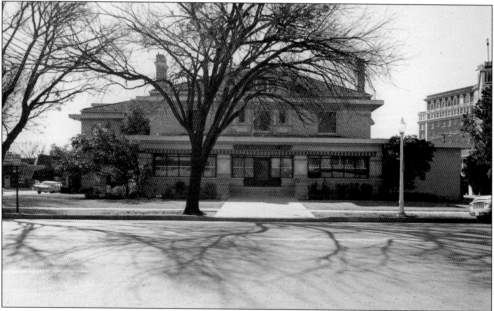

The Gause-Ware Funeral Home was expanded over the years. In 1935, the conservatory, sun porch, and kitchen were replaced with a chapel. The front porch was enclosed in 1948. The distinctive porte cochere was torn down in 1956–1957. In November 1979, a fire engulfed the building. The structure was razed in 1980. This photograph shows the funeral home in the 1960s. (UTA/Gause-Ware.)

The two-story, red brick residence at 610 Fifth Avenue is shown here in July 1965 on the eve of its demise. Built in 1905 by wholesale grocer A.E. Want, the home was purchased by Gause-Ware Funeral Home around 1931 as a residence for John Morton Ware. Contiguous to the funeral home on the south, the 11-room property was later converted to funeral home office space, then razed in 1965 for funeral parking. (UTA/FWST.)

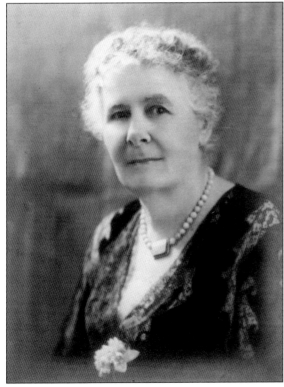

In 1922, Anna Shelton revisited an idea, abandoned 30 years previously as financially impractical, for Fort Worth clubwomen to acquire a jointly owned meeting place. On January 23, 1923, representatives from local women's organizations met to consider the proposal. As a result, the Associated Club Women of Fort Worth was chartered on July 17, 1923. The charter, amended on May 6, 1924, changed the name of the organization to the Woman's Club of Fort Worth. (WCFW.)

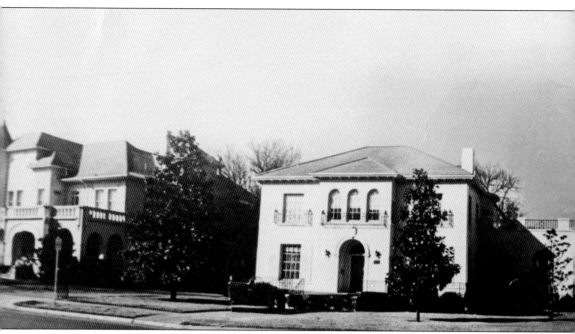

From 1923 to 1954, the Woman's Club of Fort Worth individually acquired four Pennsylvania Avenue properties encompassing an entire block, from Ballinger Street on the west to Lake Street on the east. The purchases helped to accommodate the needs of the club's growing membership. Initially a vision of Anna Shelton, the Woman's Club of Fort Worth is the steward of its campus, a hub of activity for approximately 1,500 members participating in 37 clubs and 20 departments

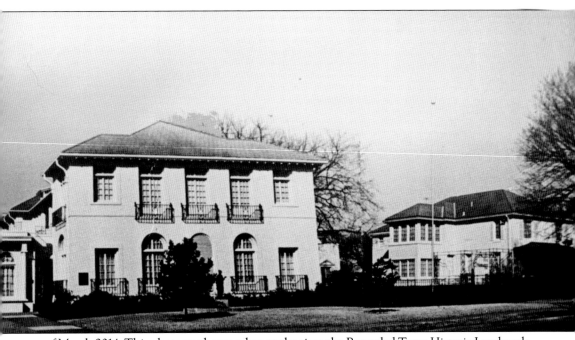

as of March 2014. This photograph was taken at the time the Recorded Texas Historic Landmark marker was placed in front of the William G. Newby Memorial Building in 1967. The properties are, from left to right, Margaret Meacham Hall (1326 Pennsylvania Avenue), Ida Saunders Hall (1320 Pennsylvania Avenue), Bewley Hall, William G. Newby Memorial Building (1316 Pennsylvania Avenue), and Florence Shuman Hall (1302 Pennsylvania Avenue). (UTA/FWST.)

For seven years, Etta Newby had been looking for a fitting memorial for her late husband, William G. Newby, former president of American National Bank in Fort Worth. She was not a clubwoman, but supported the cultural, civic, and humanitarian efforts dear to the hearts and minds of women. She found the appropriate memorial in the former residence of Heinrich Frerichs, at 1316 Pennsylvania Avenue (below). Frerichs, a German cotton broker, built the house in 1912. Traveling to Germany in 1914, the Frerichs family was not allowed to return to the United States. Heinrich Frerichs was thought to be a spy, and the home and its furnishings were seized in 1917 by the Alien Property Custodian. The Frerichs residence, along with its contents, were acquired by the Woman's Club as the William G. Newby Memorial Building in 1923 through the generosity of his widow, Etta Newby. (Both, WCFW.)

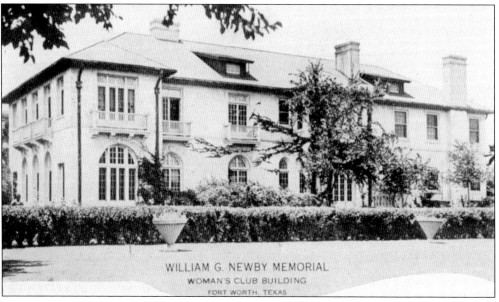

WILLIAM G. NEWBY MEMORIAL
WOMAN'S CLUB BUILDING
FORT WORTH, TEXAS

This beautiful stained-glass window was funded by male friends of W.G. Newby and installed overlooking the landing of the main stairway. Although the first program meeting was held in November 1923, the final deed was approved by the Woman's Club on May 9, 1924. It included provisions forbidding smoking by women, drinking intoxicants, and playing cards on Sunday or for money on the Newby premises. (WCFW.)

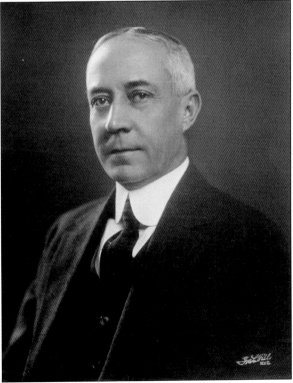

In December 1924, Anna Shelton advocated the purchase of the W.R. Edrington residence at 1302 Pennsylvania Avenue to serve as a Junior Woman's Club and to protect the Woman's Club property to the east. The purchase of the house was completed in 1925. The W.R. Edrington Bank merged with Farmers & Mechanics Bank in June 1919, shortly before Edrington (pictured) moved to New York City in July 1919. (WCFW.)

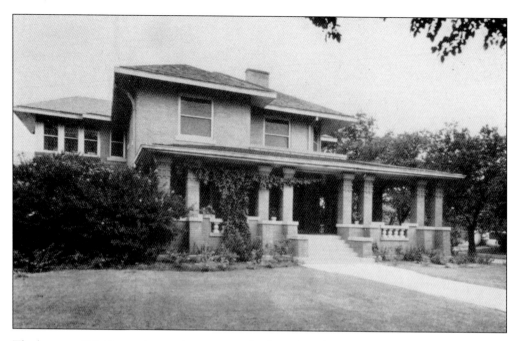

The home at 1302 Pennsylvania Avenue is said to have been built on the foundation of an earlier cottage. Banker W.R. Edrington purchased this red brick "airplane house" in April 1914 from real estate developer John C. Ryan, who sold his Pennsylvania Avenue abode to construct a new home, presumably in his new Ryan Place subdivision. The home at 1302 Pennsylvania Avenue was purchased by the Woman's Club in December 1924, and the Junior Woman's Club formally opened the building on April 8, 1927. It is pictured above sometime that year. The Junior Woman's Club continued using what is now called Florence Shuman Hall as its meeting place until moving in 1955 to new quarters at 1326 Pennsylvania Avenue, on the opposite end of the block. Shuman Hall was extensively remodeled (below) at some point, and continues to be utilized for Woman's Club activities. (Both, WCFW.)

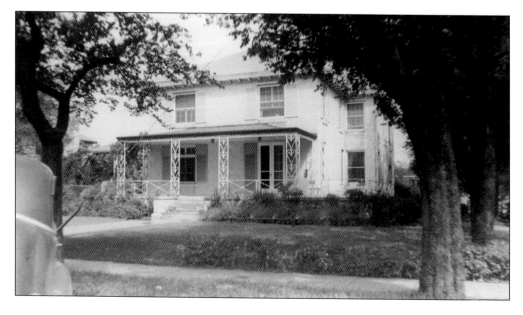

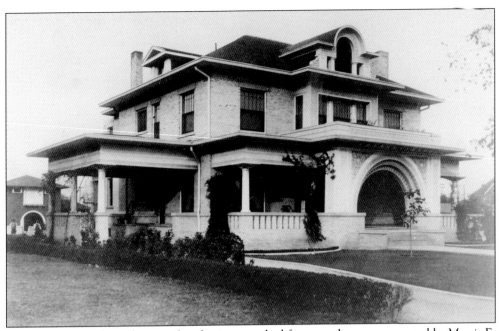

This two-story brick residence with a dominant arched front porch was constructed by Morris E. Berney at 1320 Pennsylvania Avenue from 1903 to 1904. W.R. Edrington contracted the purchase of the Berney residence for his father, Henry Clay Edrington, in April 1915 for $33,000. The elder Edrington was president of Traders National Bank and the Fort Worth Clearing House Association. H.C. Edrington died in a tragic accident in the Texas & Pacific railroad yards while walking home to his new Pennsylvania Avenue residence in May 1915. His estate was valued at $1.4 million. The Woman's Club of Fort Worth purchased the property in 1929 and extensively remodeled what is now known as Ida Saunders Hall (below). Bewley Hall and a gallery connecting Saunders Hall to the William G. Newby Memorial Building were later added. (Above, UTA/FWST; below, UTA/McGar.)

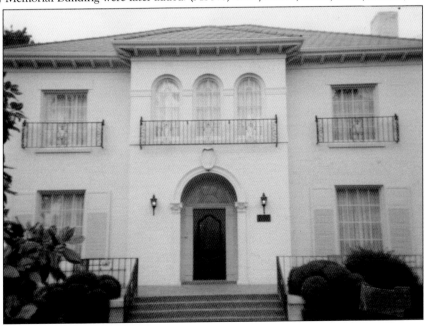

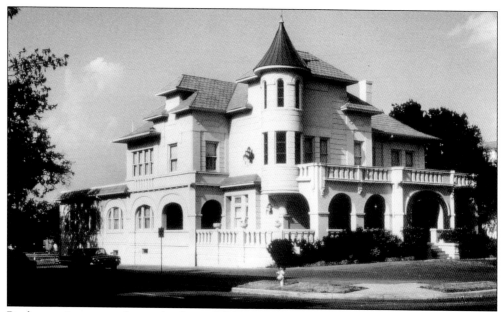

Real estate investor and capitalist James F. Moore engaged L.B. Weinman to design his residence at 1326 Pennsylvania Avenue. Construction began on the home, originally a red brick structure trimmed with white stone, in December 1905. Morgan Evans was the contractor for the original $20,000 project. Used as a funeral home since 1929, the Woman's Club purchased the home in 1954 as the future home of the Junior Woman's Club. Now Margaret Meacham Hall, the house is pictured here in 1967. (BLL.)

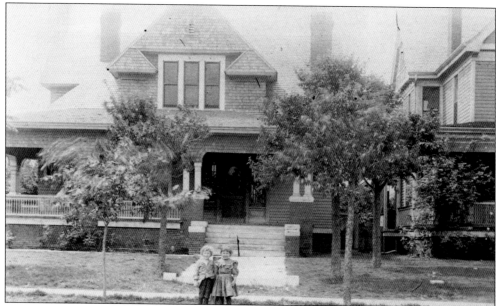

Louis B. Weinman purchased a lot in the Sandige Addition in 1899. Destined to be one of Fort Worth's leading architects, he designed this residence for his own family. It was one of the earliest houses built on Pennsylvania Avenue. Born in Germany, Weinman worked with architects in Kansas City and San Antonio before moving to Fort Worth for employment with A.N. Dawson in 1891. Weinman started his own practice in 1896. (AW.)

The Weinmans lived at 1311 Pennsylvania Avenue, just across the street from the four homes that now comprise the Woman's Club of Fort Worth. The photographer who snapped one of the Weinman sons bicycling along Pennsylvania Avenue also captured a rare glimpse of the original facades of Berney house at 1320 Pennsylvania Avenue (right) and its neighbor, the Moore residence at 1326 Pennsylvania Avenue. The Weinman residence is pictured below on the right end of the row of houses dressed in snow. This view provides another rare glimpse, this time of the south side of Pennsylvania Avenue, looking east toward the Neil P. Anderson home in the distance. Louis Weinman maintained an active architectural practice through 1938 or so. He is responsible for the design of many notable Fort Worth buildings and Quality Hill homes. His grandson Arthur Weinman followed in his footsteps. (Both, AW.)

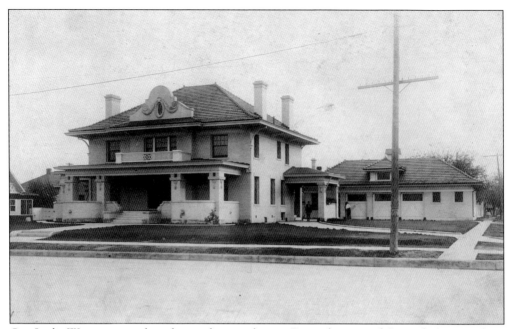

Guy Leslie Waggoner purchased two adjoining lots on Pennsylvania and Seventh Avenues from K.M. Van Zandt and J.N. Clements in June 1908 for a total of $17,000. By August, a newspaper reported that a fine new $25,000 residence was under construction. Waggoner sold his home at 1433 Pennsylvania Avenue (pictured) to Tom B. Owens two years later for $47,000. By 1919, the property had been sold to Lee Russell and B.S. Walker. (UTA/FWST.)

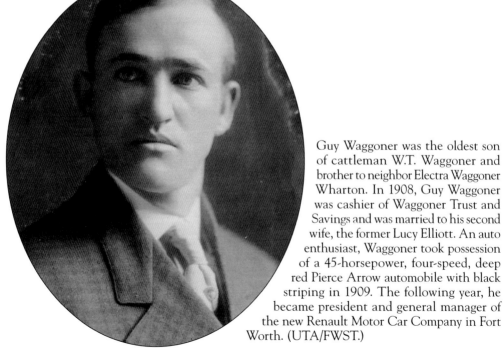

Guy Waggoner was the oldest son of cattleman W.T. Waggoner and brother to neighbor Electra Waggoner Wharton. In 1908, Guy Waggoner was cashier of Waggoner Trust and Savings and was married to his second wife, the former Lucy Elliott. An auto enthusiast, Waggoner took possession of a 45-horsepower, four-speed, deep red Pierce Arrow automobile with black striping in 1909. The following year, he became president and general manager of the new Renault Motor Car Company in Fort Worth. (UTA/FWST.)

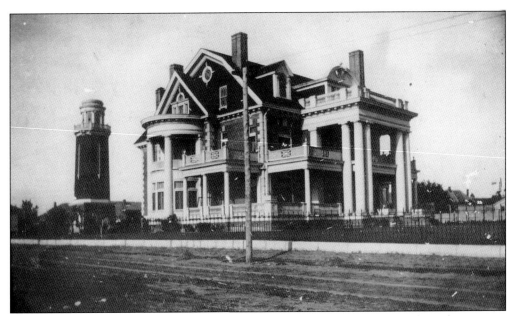

The above photograph is a rare early view of Thistle Hill from the east. It was from this vantage point that Guy Waggoner would look across Seventh Street to the home of his sister, Electra Waggoner Wharton. Note the three-story water tower at the back of the property. Portions of the fencing, wrought iron with a scored cement base, are still extant. The Guy Waggoner residence is visible in the below photograph, which looks east from Thistle Hill. This photograph clearly illustrates the setback of Thistle Hill compared to all the other homes on Pennsylvania Avenue. The Whartons purchased two separate land parcels in order to accommodate the grand placement of their new home. (Above, MD; below, HFW.)

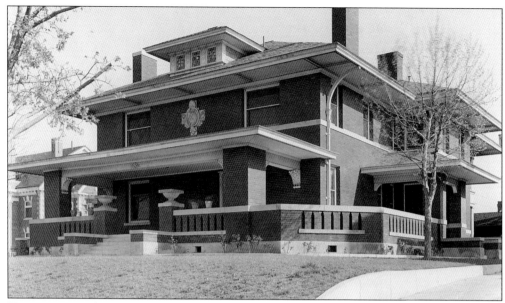

Having garnered extensive interests in cattle ranching and banking in Midland, George E. Cowden retired to Fort Worth in 1907. He built this Prairie-style, red brick residence at 1519 Pennsylvania Avenue around 1909. Cowden's son lived in a smaller but similar home next door. In Fort Worth, Cowden continued in banking and other business endeavors and maintained ranch properties encompassing 60,000 acres. He was noted for his philanthropy to religious and educational institutions. (Acme Brick.)

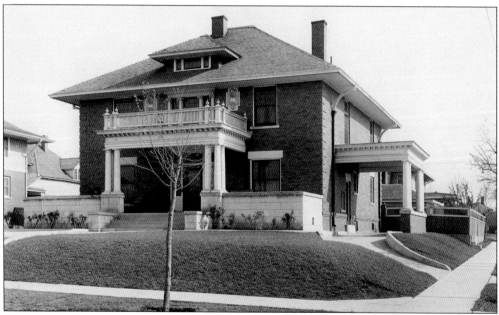

Cattleman Furd Halsell built this eclectic brick home at 1535 Pennsylvania Avenue. The Sanguinet and Staats design featured corner quoins and Doric columns supporting the front porch and porte cochere. The Halsell family was long associated with the Waggoners in Wise County. Furd Halsell moved his ranching interests in Foard, Knox, and Clay Counties to Fort Worth in 1906. The house was razed in 1961 to make way for a convalescent home. (Acme Brick.)

Six

THISTLE HILL
1509 PENNSYLVANIA AVENUE

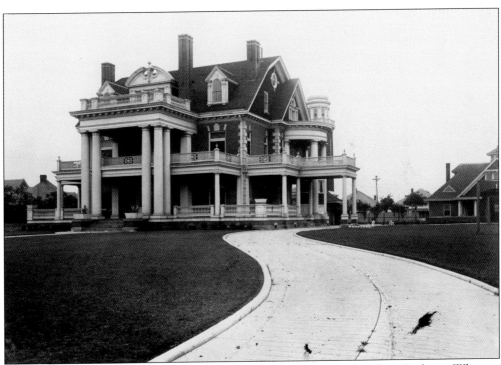

Sanguinet and Staats designed this stately Colonial Revival residence for Albert Buckman Wharton and his wife, the former Electra Waggoner. Completed in 1904 at a cost of $38,000, the residence has 25 rooms, 6 baths, and just under 12,000 square feet. The red brick exterior was trimmed with limestone, white painted woodwork, and green shake shingles. Visible at far right is its rare transitional carriage house/garage, built to house automobiles, carriages, and horses. (HFW.)

Electra Wharton, the only daughter of cattleman W.T. Waggoner, was described in Dallas society magazine *Beau Monde* as one of "Texas' greatest heiresses . . . a decidedly attractive girl, being Gibsonesque in figure and pose, with a wealth of rich brown hair and glorious grey eyes . . . her extensive travel and brushing up against the people of the world has given her that cosmopolitan air that sets so well on the American girl." (HFW.)

The Whartons were known for lavish, themed parties that lasted well into the morning and included dancing in the third-floor ballroom. Always the quintessential hostess, Electra is pictured here dressed in Grecian costume, lying in repose atop a leopard-skin throw. It is said that she was the first to spend $20,000 in a one-day shopping spree at Neiman Marcus in Dallas; that she purchased clothes from Paris and New York; and that she never wore the same garment twice. (HFW.)

A.B. Wharton met Electra Waggoner while both were on grand tour in the mountains of Nepal outside Katmandu in 1900. They continued their travels together and were soon engaged. The June 1902 wedding announcement listed Wharton as a "Philadelphia capitalist" and "reckoned the groom to be a wealthy man." While in Fort Worth, he traded in downtown real estate and won several two-in-hand driving competitions. (HFW.)

NOTICE CATTLEMEN

Automobiles
For Rent
BY THE DAY OR HOUR

Wintons, Franklins, Orient Buckboards and Motor Cycles for sale.

Fort Worth Auto Livery

Telephone 2542.　　　404 HOUSTON STREET.

A March 6, 1904, article in the *Fort Worth Telegram* noted: "A.B. Wharton is the owner of the Fort Worth auto livery and his establishment on upper Houston Street is one of the best equipped of its kind in the state of Texas. The livery has now been in operation about sixty days." This advertisement ran the following day, pitching Winton and Franklin automobiles, Orient buckboards, and motorcycles. (FWPL.)

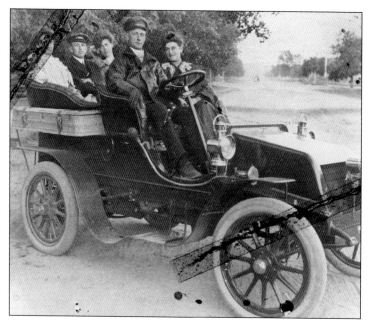

Sitting in the front seat of this 1903 Winton automobile are chauffeur Roy Kamp and Electra Waggoner Wharton. A.B. Wharton is sitting in the back seat between two female friends. He and Kamp made an adventurous trip from Denver to Fort Worth in this touring car, despite primitive road conditions. The Winton Motor Carriage Company was incorporated in 1897 and manufactured automobiles through 1924. (SR.)

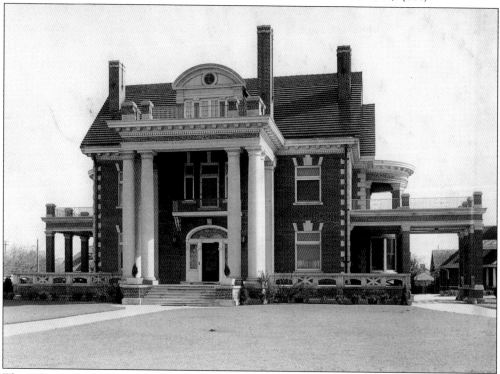

The Whartons sold Thistle Hill to Winfield and Elizabeth Scott in 1911 for $90,000. The Scotts commissioned Sanguinet and Staats to transform the mansion to Georgian Revival splendor. Primary changes included removal of the second-floor balcony, dormer windows, and all Colonial-style woodwork. Limestone columns were added on the front portico, and green terra-cotta tile roofing was installed. Dallas photographer Charles Erwin Arnold documented the 1912 remodel project for Acme Brick. (Acme Brick.)

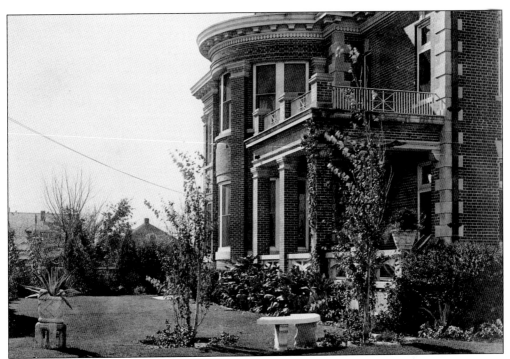

Recently widowed, Elizabeth Scott moved into Thistle Hill with her son Winfield Scott Jr. Her eastside garden featured a concrete bench and planter with a faux bois base. The planter has been reproduced and is a perfect height for the current Children's Sensory Garden. Bay windows on both east and west sides of the house contain 12 panes of convex glass, creating a beautiful panoramic view of the exterior. (HFW.)

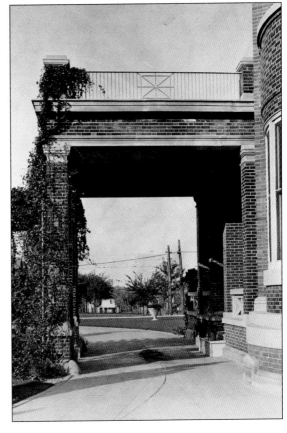

The porte cochere protected those arriving at Thistle Hill from inclement weather. The first step of the side porch is "carriage height." When exiting a tall carriage or automobile, one would step out evenly onto the staircase to enter the house. Elizabeth Scott lived at Thistle Hill until her death in 1938. This photograph was taken around 1940. The English ivy would never have been so unruly during her tenure. (HFW.)

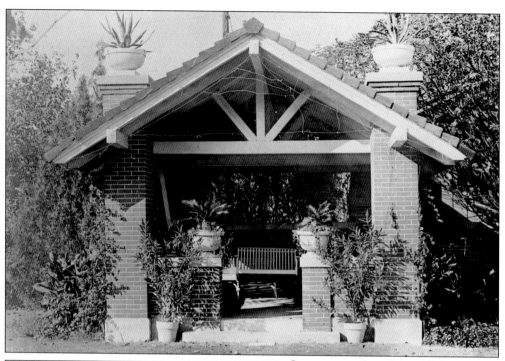

Structures such as this gabled teahouse were designed as much for shade as ornamental garden elements adding texture and folly to landscape designs. The teahouse, built after the 1912 remodel, features the same terra-cotta tile roof found on the main house. Rooftop pots and wire await its climbing foliage. On hot afternoons, the family would retreat outdoors for refreshments and the pleasant Texas breeze. (HFW.)

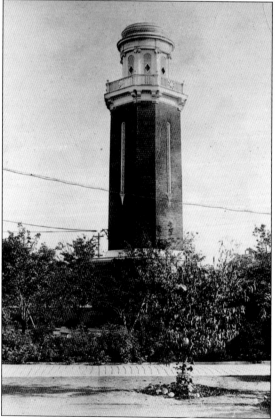

This octagonal water tower stood at the back of the property. Built in the shape of a lighthouse, it was sheathed in green wood shingles. The three-story structure operated on a gravity-feed system, which forced water all the way to the third floor staff quarters in the main house. The tower was demolished after a heavy storm in the 1940s; all that remains is its foundation. (HFW.)

Elizabeth Scott built this pergola to enhance her gardens. It extends 40 feet from the west side of the porte cochere and is over 11 feet tall. Covered in climbing roses, a lattice-enclosed seating area awaited the visitor at the end of her walk. The pergola was lost in subsequent years, but it was reconstructed by Historic Fort Worth, Inc., in 2008. (HFW.)

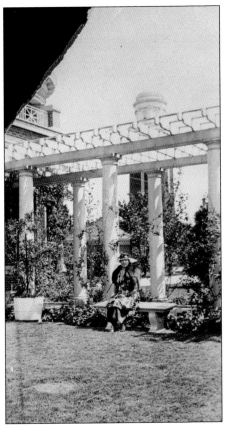

Elizabeth Scott took great pride in her English-style gardens. Although a gardener is often listed in residence, she was very much involved in the upkeep. The grounds of Thistle Hill were frequently listed in local tourism brochures during her lifetime. Elizabeth Scott is pictured on the west lawn beneath the pergola around 1928. (HFW.)

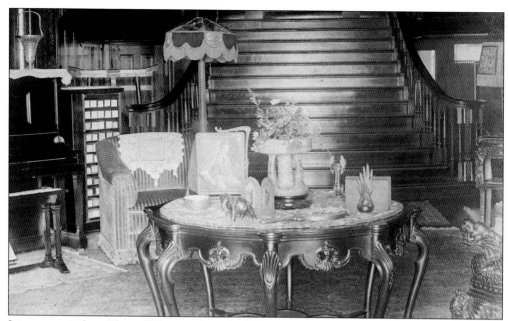

It is uncertain how Electra Wharton furnished this spacious foyer. During the Scott years, it was used as an eclectic sitting room. The room was appointed with numerous carved wooden tables and chairs, as well as a pump player piano complete with a cabinet full of music rolls. In the below photograph, the formal parlor fireplace is visible through the portiere-draped doorway. The Rococo Revival detailing of the parlor is clearly seen here, as are the fine Persian rugs, statuary, and numerous textures that would complete an opulent turn-of-the-century interior. Today, Thistle Hill is furnished in the style of the Scott interior decor. (Both, HFW.)

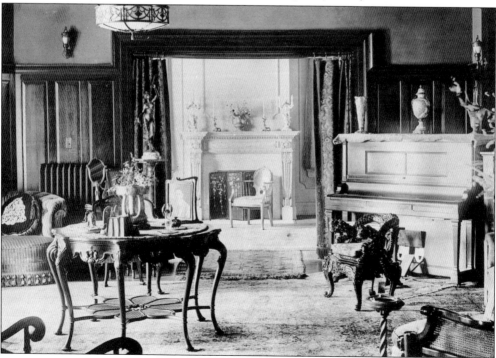

Mahogany paneling sets the drawing room or parlor apart from others in the house. The Whartons used a green color palette in this room, accented by stained woodwork. Elizabeth Scott selected the Rococo Revival decor, painted the woodwork, changed the colors to gray and mauve, and added the plaster garlands and curly maple flooring. Recreating rooms seen in Europe was a common way to showcase one's "souvenirs" from abroad. (HFW.)

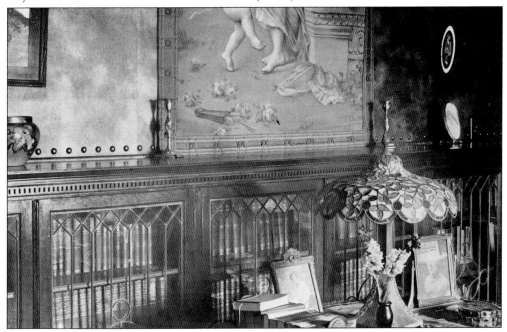

The room to the right of the foyer was used by the Whartons as a gentlemen's retreat. During the Scott years, this room was the library. The walls feature a leather-like faux finish, similar to the original. The furnishings were lined with photographs, knickknacks, and pottery. The table lamp is Tiffany in style and has been returned to the mansion. (HFW.)

The morning room enjoys radiant morning sunlight. Added by the Scotts during the 1912 remodeling, the morning room was used for informal dining. It was also the perfect place for planning dinner-party menus and guest lists. The hutch was filled with a variety of china patterns. Elizabeth Scott loved to host monochromatic dinner parties and would have had numerous colors from which to choose. (HFW.)

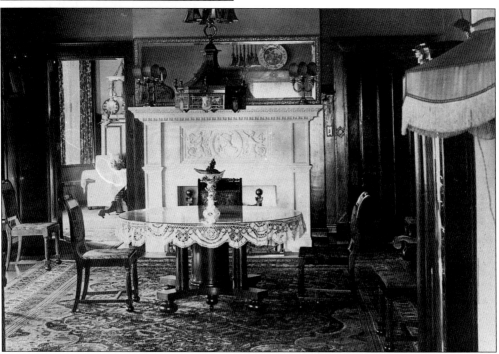

Both the Wharton and Scott families entertained elegantly in this dining room. Guests entering from the drawing room were seated at a large round dinner table. Other furnishings included a china cabinet, sideboard, and tea cart. The dining room wainscoting is a faux-green leather with a plate rack above in the Arts and Crafts style. The morning room is visible through the doorway. (HFW.)

Visible from a single vantage point, there are five fireplaces on the first floor of Thistle Hill, each with its own architectural design. This dining-room fireplace, over five feet tall and seven feet wide, is the focal point of the room. Cast in plaster, it features Greek decoration and traditional egg and dart trim. None of the fireplaces are wood-burning; they burned coal and were later converted to gas inserts. (HFW.)

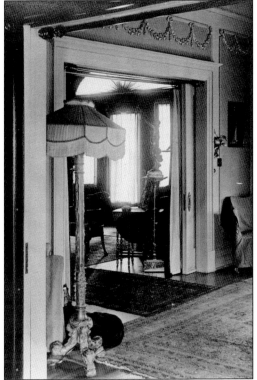

The stately entrance at Thistle Hill was designed to impress visitors and increase the amount of light in the large entry hall. The wide beveled-glass door is flanked by leaded-glass sidelights featuring a double-wedding-ring motif. This motif is repeated throughout all the glasswork, as the home was a wedding gift to Electra from her new husband. The whole space is surmounted by a massive, nine-foot leaded-glass fanlight. (HFW.)

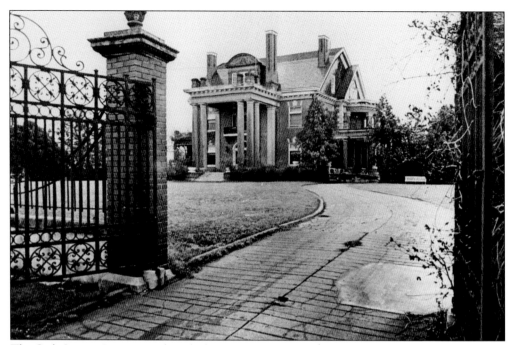

The Girls Service League purchased Thistle Hill in 1940 for $17,500. Up to 33 young women lived in the mansion with a housemother and staff. Many worked as riveters for Consolidated-Vultee Aircraft during World War II. With little money to spend on changes, the Girls Service League is to be credited for maintaining the home's original interiors. With the exit of the Girls Service League, Thistle Hill was in grave danger of becoming another victim to progress. Save the Scott Home was created as a grass-roots effort to save the mansion. Shortly after acquiring the property in 1976, the organization's name was changed to Texas Heritage, Inc. It restored and maintained the mansion for 30 years, until it was gifted to Historic Fort Worth, Inc., in 2006. Thistle Hill is pictured above during the Girls Service League tenure in December 1940. Its elegant stairway (below) was photographed by Byrd Williams around 1995. (Above, UTA/FWST; below, FWPL.)

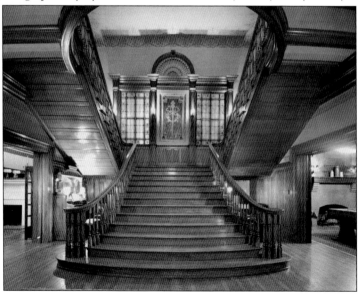

Seven

OTHER SOUTHSIDE STREETS

John Bunyan Slaughter, a wealthy Colorado City cattleman and banker, purchased the south half of Block 45, Jennings South Addition, from Hyde Jennings for $5,600 in June 1897. The following September, Slaughter obtained a building permit to erect a "handsome" 15-room home estimated to cost $17,000. Slaughter rented the nearby home of Judge I.W. Stephens while awaiting the completion of his new residence. (HWTM.)

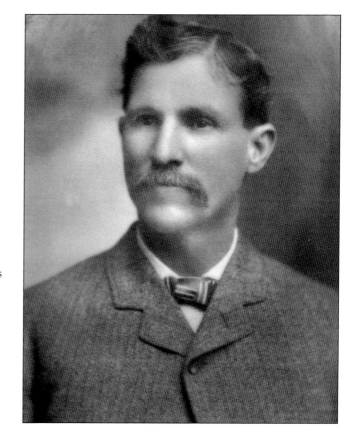

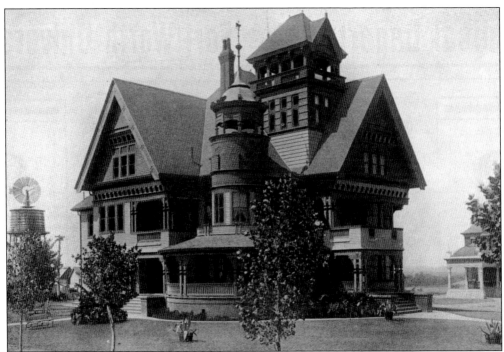

Slaughter's stunning frame residence, depicted above in a 1902 Cattle Raisers Association program, featured many Victorian design elements: bay windows, circular rooms, turrets, gables, and elaborate chimneys. About 1904, Slaughter sold the house at 556 Hill Street (later South Summit Avenue) to William Reeves for $20,000 plus 585 acres of land. Slaughter moved to his Square and Compass Ranch in Garza County, where he lived until his death in 1928. Reeves was probably responsible for the extensive remodeling of the house, transforming it from a Queen Anne mansion to a home with simpler Neoclassical lines then in vogue, although the original footprint appears to have been maintained. The new exterior (below) was highlighted in the book *Industry and Commerce of Fort Worth*, published in 1905. Reeves lived in the house for two years and then sold it to W.T. Waggoner for $32,500 in March 1906. (Above, JG; below, UTA/FWST.)

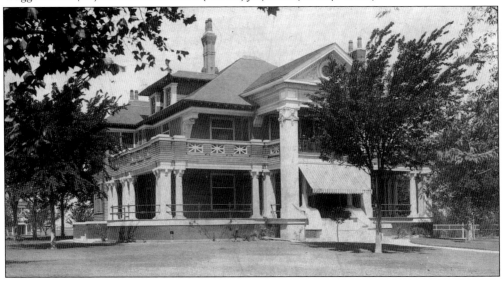

W.T. Waggoner transferred ownership of 556 South Summit Avenue to his son E. Paul Waggoner by 1913, when his new residence at 1200 Summit Avenue was completed. Casswell O. Edwards purchased the house from the younger Waggoner in February 1918 for $30,000. A 1948 newspaper account reports that Edwards bought the now-17-room brick residence for his bride, the former Mollie Childers. C.O. Edwards (pictured) was a Tarrant County rancher and landowner. (UTA/FWST.)

Mollie Edwards lived in the house until 1948. Her library, pictured that October, was a comfortable room with curly maple woodwork. The mirrored fireplace overmantel was built of the same curly maple. Intricate tile surrounded the firebox. *Trail Drivers of Texas*, along with popular titles, a zippered well-used Bible, and Oriental keepsakes line the bookshelves. The portrait of her husband, pictured at right, graces the wall at left. (UTA/FWST.)

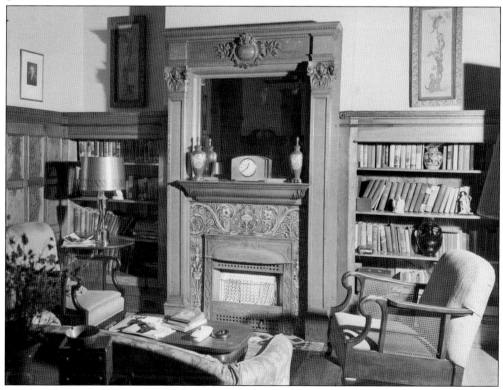

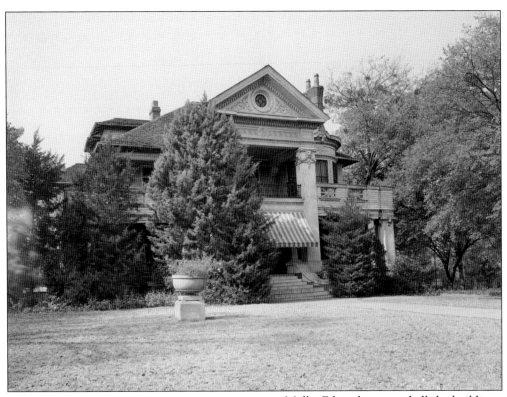

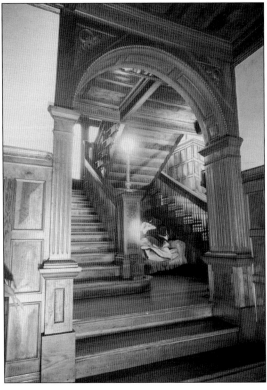

Mollie Edwards reserved all the buildings on the property when she sold her home in 1946 to Bryan Hanks. Hanks purchased the entire block, comprised of the Edwards and adjacent O'Keefe residences, planning a medical complex. She lived in the house until 1948, when it was painstakingly dismantled for reuse in her new Westover Hills residence. These photographs were taken in October 1948 for a *Fort Worth Star-Telegram* feature article as preparations were being made to salvage the architectural components of the structure. The focal point of the ground floor was a massive double stairway (left) crafted of hand-turned curly maple. It is seen here from the library. Intricate stained-glass windows illuminated the "roomsize" stairway landing. The fireplace (opposite page) appears to have warmed a bedroom. Its Monarch liner was patented in July 1897, clearly a remnant from the J.B. Slaughter construction. (Both, UTA/FWST.)

The old Edwards house yielded 40,621 board feet of lumber and 40,000 bricks. Brick from the chimneys and basement partitions were odd-sized and were relegated to less visible use in the new residence, located at 39 Valley Ridge Road. Among the repurposed items were 58 heavy oversize doors, hand-decorated Dresden china bathroom tiles, and cast bronze hardware. Said to have been rebuilt exactly, with only proportional changes, were two rooms, the paneled library and the wainscoted dining room with its parquet floor. Mollie Edwards shared her home with her sisters Mrs. M.C. Chapman and Mrs. S.T. Bibb Jr. and family. Shown below are S.T. Bibb Jr., son Tommy, and their dog. They are seen "at home" in their new library. This new library and the old one (see page 119) are clearly reminiscent of one another. (Both, UTA/FWST.)

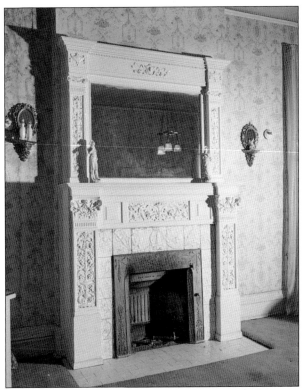

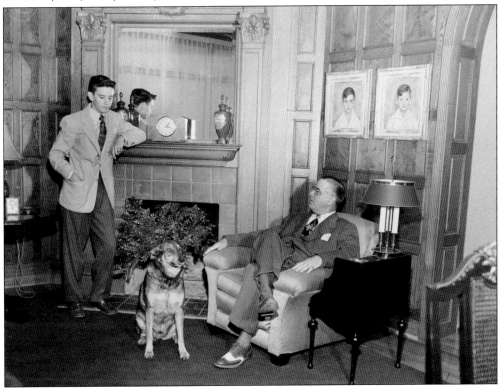

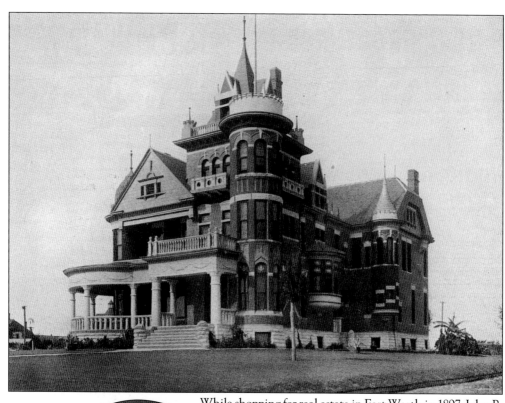

While shopping for real estate in Fort Worth in 1897, John B. Slaughter was asked by an unnamed friend and neighbor to select a second prospective property. The unnamed party was probably fellow Colorado City cattleman William T. Scott, as Scott soon acquired the land immediately north of the Slaughter homesite and constructed the equally magnificent red brick Queen Anne home designed by architect Louis B. Weinman in 1902. (JG.)

C.A. "Gus" O'Keefe, also a Colorado City cattleman and banker, had major ranch holdings and was noted as having a fine herd of Hereford and Shorthorn cattle. He moved his family to Fort Worth in the fall of 1905 so his children could attend good schools. A year later, William Scott's widow, Minna Scott Hyman, sold her residence at 520 Hill Street (later South Summit Avenue) to her O'Keefe cousin for $30,000. (SB.)

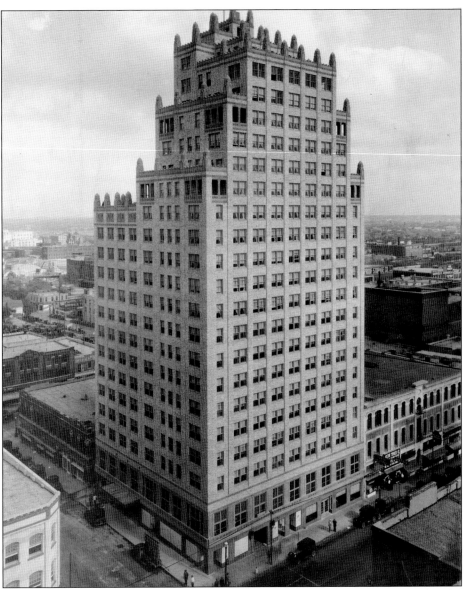

Shortly after moving to Fort Worth, O'Keefe was plagued with illness he attributed to long hours spent in the saddle. Although he suffered physical handicaps and was often confined to his bed, he maintained an active business life and invested heavily in Fort Worth real estate, including Binyon-O'Keefe Storage and the Blackstone Hotel (pictured), which opened just prior to his death in October 1929. Fort Worth's first Art Deco skyscraper was designed by Elmer Withers in collaboration with the St. Louis firm Mauran, Russell, and Crowell. It was built with fireproof reinforced concrete faced with buff-colored brick and terra-cotta tile detailing. The hotel hosted many luminaries, including Presidents Herbert Hoover and Richard Nixon and entertainers Clark Gable, Benny Goodman, and Bob Hope. Bob Wills recorded his classic hit "San Antonio Rose" from the WBAP radio studios on the top floor in 1938. Vacant for nearly 20 years, the Blackstone reopened in 1999 with a new life as a Marriott Courtyard hotel. Granted a facade easement, Historic Fort Worth, Inc. is a partner in preserving the integrity of the Blackstone's exterior appearance. (UTA/Jack White.)

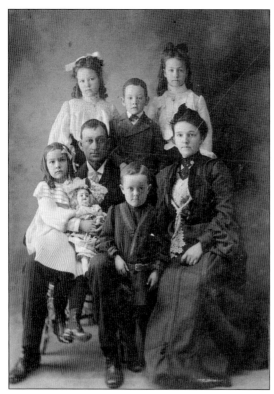

Josephene McMillon married Gus O'Keefe in Colorado City in March 1891. The O'Keefe family, pictured at left sometime between 1903 and 1905, included daughters Gussie, Pattie, and Alice and sons Joe T. and John David. Josie O'Keefe was an active member of First Methodist Church in Fort Worth and donated funds to build the church's Wesley Hall in memory of her husband and her grandfather, Rev. John Wesley Chalk, the first pastor of the church. Josie O'Keefe also belonged to the Woman's Club of Fort Worth and founded the Boys Club in 1931. Her travels included four world cruises and many trips across the United States. Perhaps her world travels inspired Josie O'Keefe to host a garden party in which guests dressed in international costume. She posed as a flirty señorita in the undated photograph below. (Both, SB.)

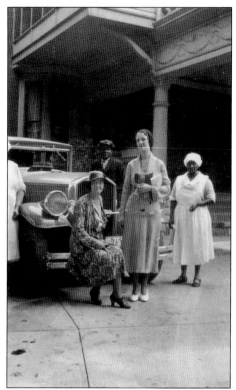

At right, Josie O'Keefe rests on the bumper of her automobile, parked in the driveway of her home, as perhaps her daughter and three staff members look on. The license plate on the car dates this photograph to 1932. O'Keefe moved into a suite in the Blackstone Hotel in 1941. During World War II, her home, including the servants' quarters, was converted into 14 efficiency apartments for wartime workers. The June 1943 photograph below indicates that the exterior elevation was modified sometime during the O'Keefe tenure; at a minimum, the square tower and front turret were lowered to the second floor. Demolition of the O'Keefe residence commenced in May 1950 to make way for the Westchester Apartments, part of a planned medical center and office complex that also encompassed the former Edwards homesite to the south. (Right, SB; below, UTA/FWST.)

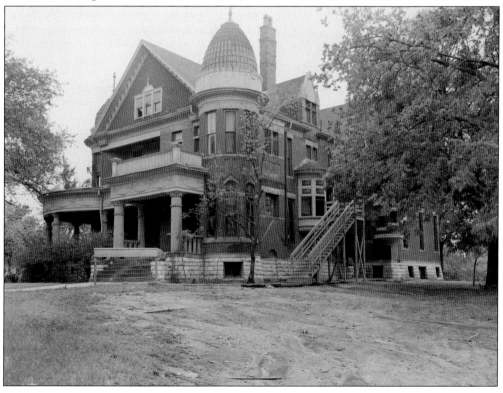

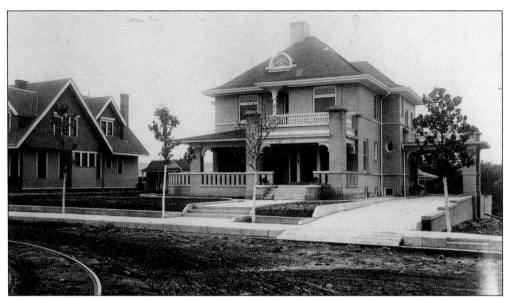

Sanguinet and Staats designed this residence at 600 South Eighth Avenue for jeweler James E. Mitchell in 1907. In 1920, the property was sold to Mitchell's friend Dr. Charles B. Simmons. He transferred ownership of the residence to his daughter Maurine and her husband, Dr. Frank Schoonover, in 1945. The Schoonovers sold the house in 1979 for commercial use as a savings and loan association and professional offices. It also became a Recorded Texas Historic Landmark that same year. Attorney Art Brender purchased the property in 1995 for his law office and commissioned architect Paul Koeppe to restore the interior in 2003. The early photograph of the Mitchell-Simmons-Schoonover residence (above) shows the trolley line track as it turned from Pennsylvania Avenue south to Eighth Avenue. The building's later use as First City Savings Association is documented below in 1979. (Above, AB; below, UTA/FWST.)

About the Organization

Established in 1969 and honored in 2009 with the Texas Historical Commission's Governors Award in Preservation, Historic Fort Worth, Inc., is dedicated to preserving Fort Worth's unique historic identity through stewardship, education, and leadership. Historic Fort Worth is the steward of two historic houses within the Quality Hill neighborhood: the 1899 Ball-Eddleman-McFarland House and the 1904 Wharton-Scott House, known as Thistle Hill.

Historic Fort Worth's administrative offices are on the second floor of McFarland House, 1110 Penn Street. The main floor serves as a historic house museum, and the lower level is the Preservation Resource Center library, comprising books, photographs, surveys, and thousands of files on historic buildings in Fort Worth. McFarland House is available to the public for tours, rentals, and research.

Historic Fort Worth's main tourism property is Thistle Hill, at 1509 Pennsylvania Avenue. Adjacent to two major hospitals and with a lot of 1.5 acres, today Thistle Hill's parklike grounds comprise the largest green space in the Medical District. On weekdays, Historic Fort Worth makes the grounds available at no charge to the family members of patients, the medical staff, and the general public. A children's tactile and fragrance garden was installed in 2008, and a weekday food truck park was added in 2013. The carriage house, one of only two urban, transitional carriage houses remaining in Texas, was built for both horses and cars and includes stalls, grain bins, a cooling yard, garage bays, and a hand-crank gas pump. Thistle Hill is available to the public for tours and rentals.

Other Historic Fort Worth programs include membership tours of private and public buildings, programs on restoration and property management, historic property research, marketing of endangered properties, preservation courses for developers and real estate professionals, preservation awards, tours of the city for special conferences, public appeals for threatened properties, historic resources survey updates, and facade easements.

In 2013, over 100,000 friends, members, and constituents engaged with Historic Fort Worth, Inc., through memberships, community programs, as tourists, and at fundraising events like Preservation is the Art of the City®, the Hidden Gardens Tour of Fort Worth, and holiday events. As a 501(c)(3) public charity, everyone is invited to join at www.historicfortworth.org.

HISTORIC FORT WORTH, INC.

DISCOVER THOUSANDS OF LOCAL HISTORY BOOKS
FEATURING MILLIONS OF VINTAGE IMAGES

Arcadia Publishing, the leading local history publisher in the United States, is committed to making history accessible and meaningful through publishing books that celebrate and preserve the heritage of America's people and places.

Find more books like this at
www.arcadiapublishing.com

Search for your hometown history, your old stomping grounds, and even your favorite sports team.

Consistent with our mission to preserve history on a local level, this book was printed in South Carolina on American-made paper and manufactured entirely in the United States. Products carrying the accredited Forest Stewardship Council (FSC) label are printed on 100 percent FSC-certified paper.

MADE IN THE

USA